P9-DNO-415

OCT ' 2016

CH

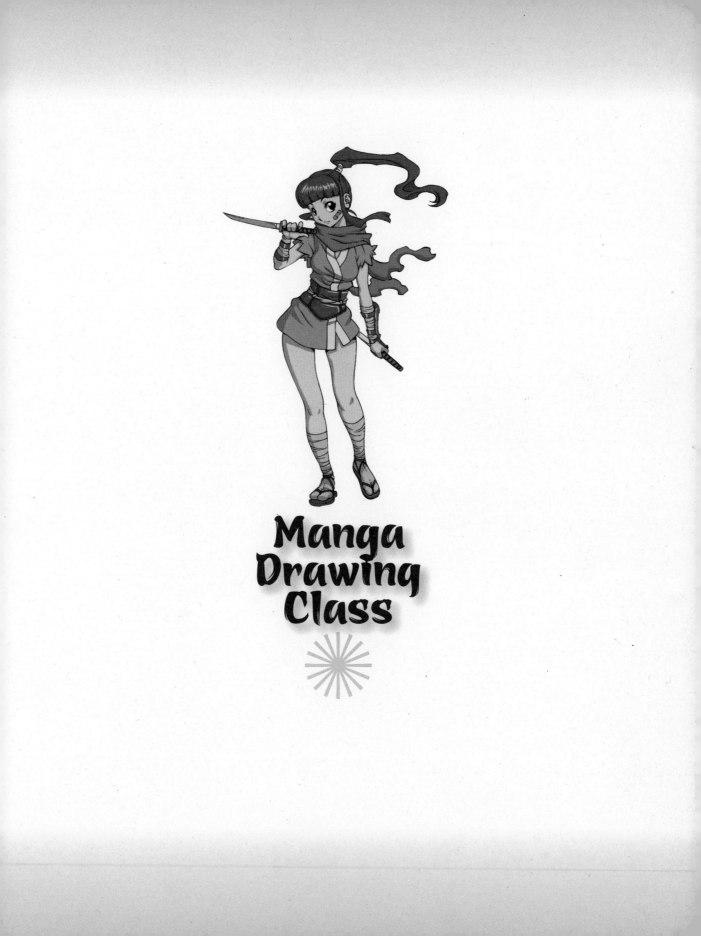

Manga
Drawing
Class

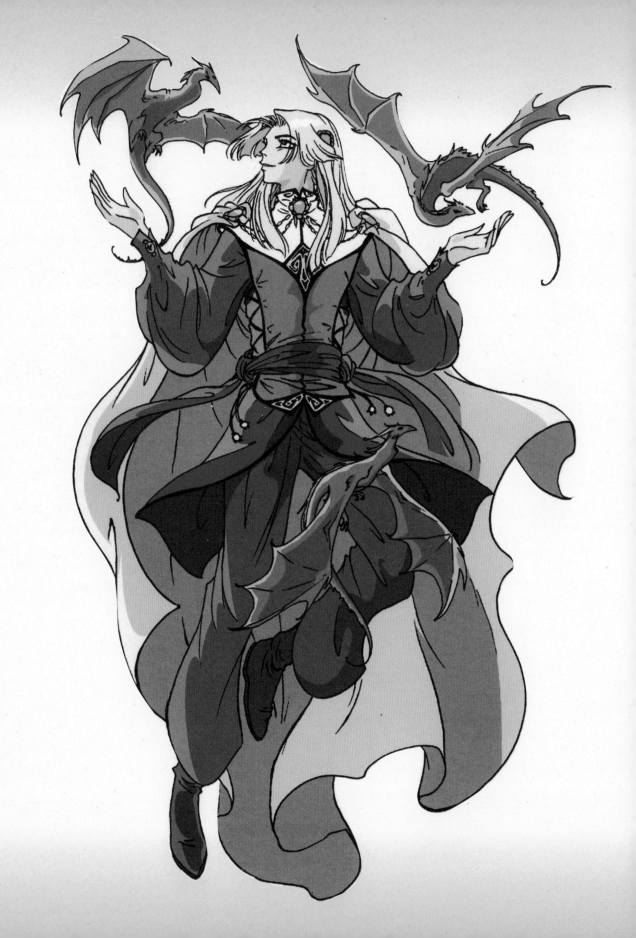

DRAWING WITH Christopher Hart

Manga Drawing Class

A Guided Sketchbook for Creating Fantasy & Adventure Characters

sixth&spring
books
NEW YORK

DRAWING WITH Christopher Hart

An imprint of Sixth&Spring Books
161 Avenue of the Americas, New York, NY 10013
sixthandspringbooks.com

Managing Editor
LAURA COOKE

Book Design
JUSTINE STRASBERG

Contributing Artists
ANZU
DENISE AKEMI
SVETLANA CHMAKOVA
VANESSA DURAN
TIM ELDRED
DAN FRAGA
CHRISTOPHER HART
MAKIKO KANADA

JANG SEOK KIM
JIN SONG KIM
CHEOL JOO LEE
RUBEN MARTINEZ
CHIHIRO MILLEY
JENNYSON ROSERO
DIOGO SAITO
KRISS SISON
NAO YAZAWA

Editor
LAURA COOKE

Senior Editor
LISA SILVERMAN

Art Director
DIANE LAMPHRON

Editorial Assistant
SARAH THIENEMAN

Vice President
TRISHA MALCOLM

Production Manager
DAVID JOINNIDES

Publisher
CAROLINE KILMER

President
ART JOINNIDES

Chairman
JAY STEIN

Library of Congress Cataloging-in-Publication Data
Hart Christopher, 1957-
Manga drawing class: a guided sketchbook for creating fantasy & adven-
ture characters / Christopher Hart. – First edition.
 pages cm
ISBN 978-1-936096-87-9
1. Comic books, strips, etc.–Japan–Technique. 2. Figure Drawing–Tech-
nique. 3. Fantasy in art. I. Title.
NC1764.5.J3H36943 2015
741.5'10952--dc23
 2014040853
Manufactured in China
13 5 7 9 10 8 6 4 2
First Edition

To all my fellow
manga fans

–Christopher

Contents

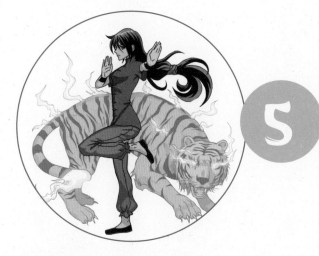

Introduction

You're about to take a journey into the world of fantasy and adventure. All of your favorite characters are here, from fairies, angels, and princesses to demons, animal spirits, wizards, and more. There's even a collection of fun chibi characters to draw. The last chapter, "Beyond Tomorrow," takes you into the future with the latest trends of the fantasy genre. But the adventure never ends. The information and techniques within these pages will be a valuable asset in your growth as a manga artist.

And you'll get expert instruction. Christopher Hart, the world's best-selling how-to-draw author, teaches with a friendly and engaging manner, coupled with an abundance of step-by-step illustrations. In almost no time, you'll see your drawings improve and come to life.

Manga Drawing Class makes practicing something to look forward to. In addition to illustrated art instruction, this book contains quality sketch paper throughout that is perfect for pen or pencil drawing. Now you can follow the steps without having to scramble to find more paper. The book provides it for you.

You're about to set sail on a sea of imagination. Let the voyage begin!

Fairies

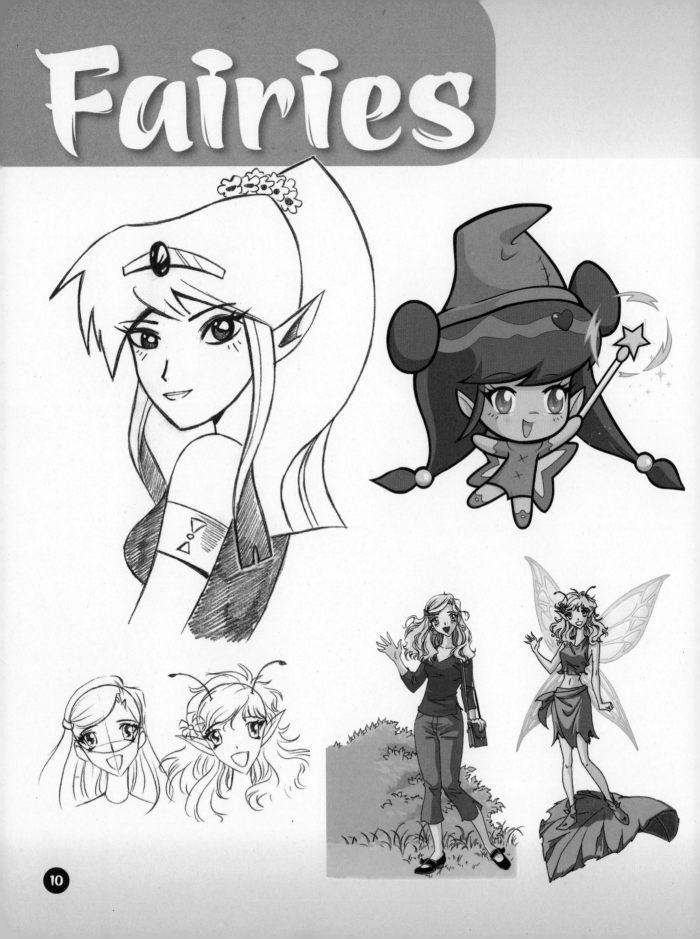

Fairies are among the best-loved characters in the manga fantasy genre. The tiny inhabitants of nature's smallest kingdom exude gracefulness and charm. We'll learn how to capture an enchanted look in our drawings. All fairies have different roles and different personalities too, from ordinary villagers to fairy queens and defenders of the realm.

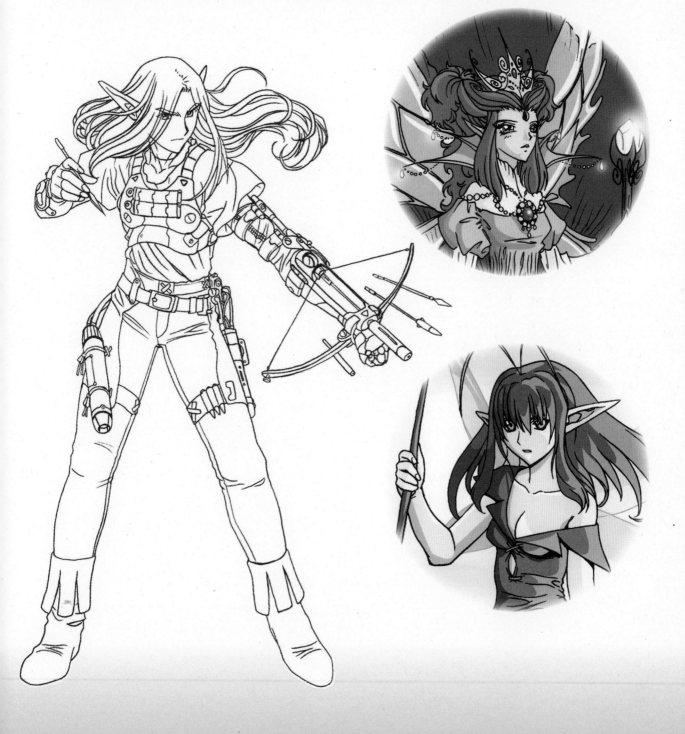

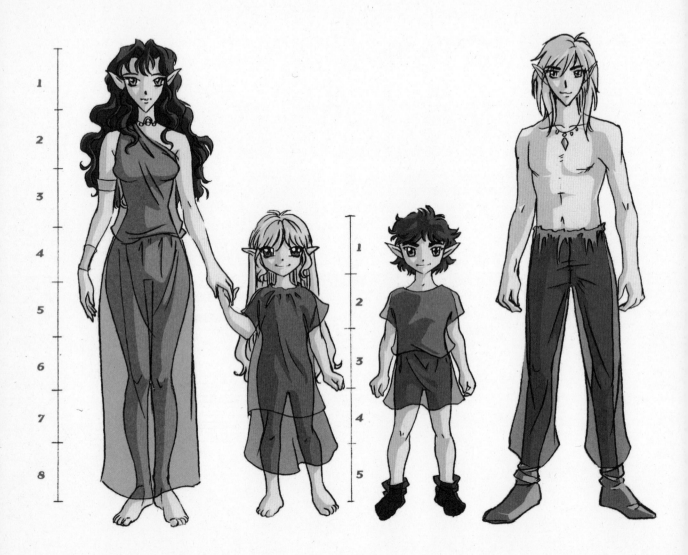

Let's start by observing the proportions among a family of fairies. Adult fairies are drawn at an elongated 8 units, or "8 heads tall," which gives them a graceful appearance. (Realistic people are 7 heads tall.) By contrast, toddler fairies are only 5 heads tall, which means that they're more compact (and cuter!).

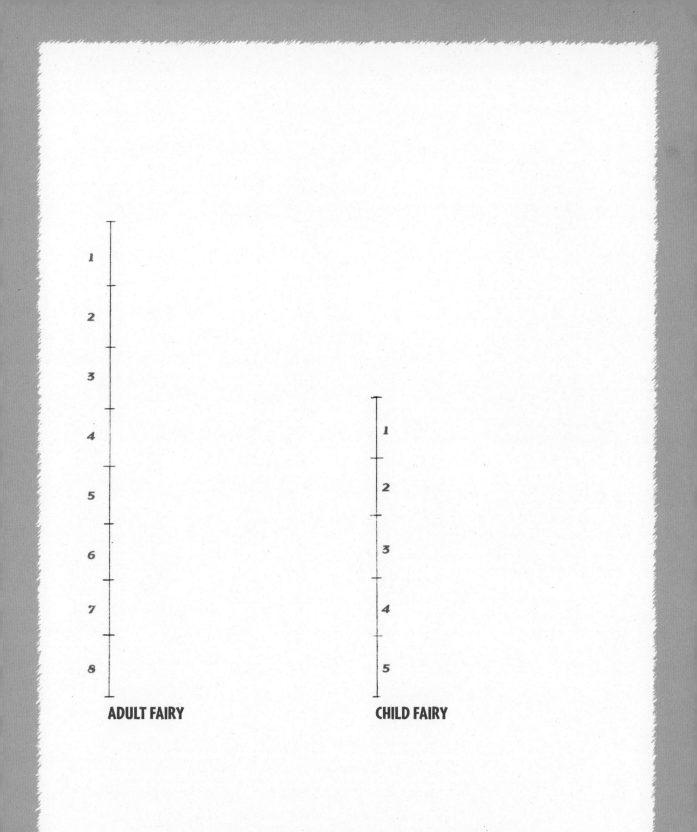

ADULT FAIRY

CHILD FAIRY

Draw your fairies along these proportion guidelines.

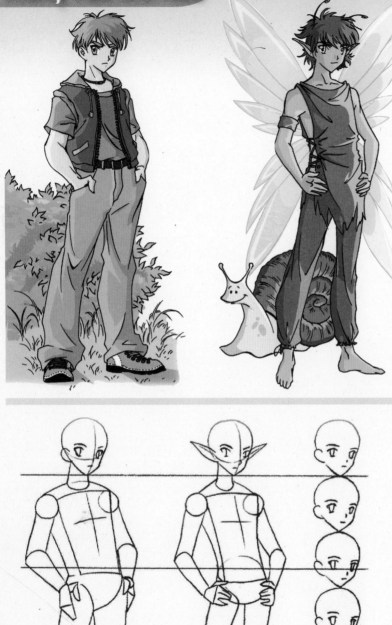

A fairy isn't just a human with pointed ears. Fairies are slimmer and lighter than humans; they have to be so they can fly. Their faces are slightly thinner and longer, and their features are pointed (eyes and nose). You can also add antennae. The wings are often translucent (partially see-through). Being creatures of nature, many manga fairies go around barefoot. And their clothes look like stuff you would have gotten at a thrift shop in Robin Hood's day.

Practice Page

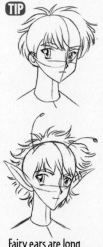

Fairy ears are long,
unlike the tiny pointed
ears of demons.

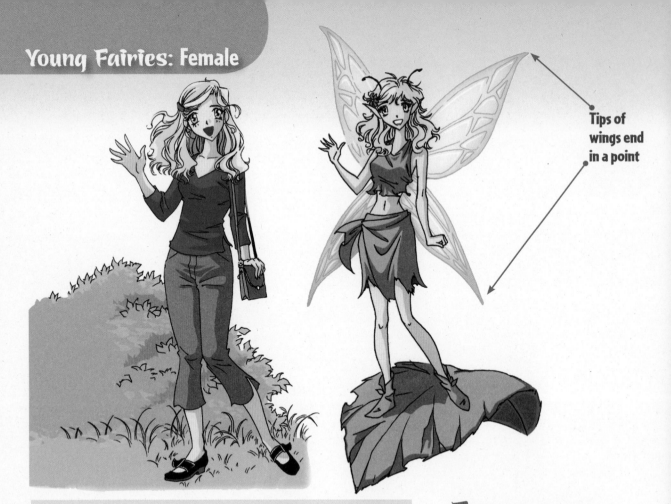

Tips of wings end in a point

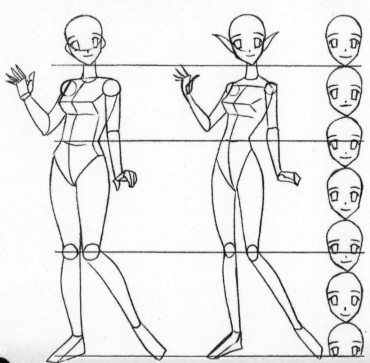

Fairies are drawn with a slighter build than their human counterparts. This girl fairy stands on a leaf, which shows not only her size but also suggests how light she is. The slender build is combined with oversized wings.

Practice Page

TIP

Her hair is breezy and natural looking. A flower or jewel in the hair is popular.

The female's face is elegant. Her jawline is drawn with a soft, curved line. The eyes are large and bracketed by dark, thick eyelashes. Note how the wavy hair falls in front and behind the ears.

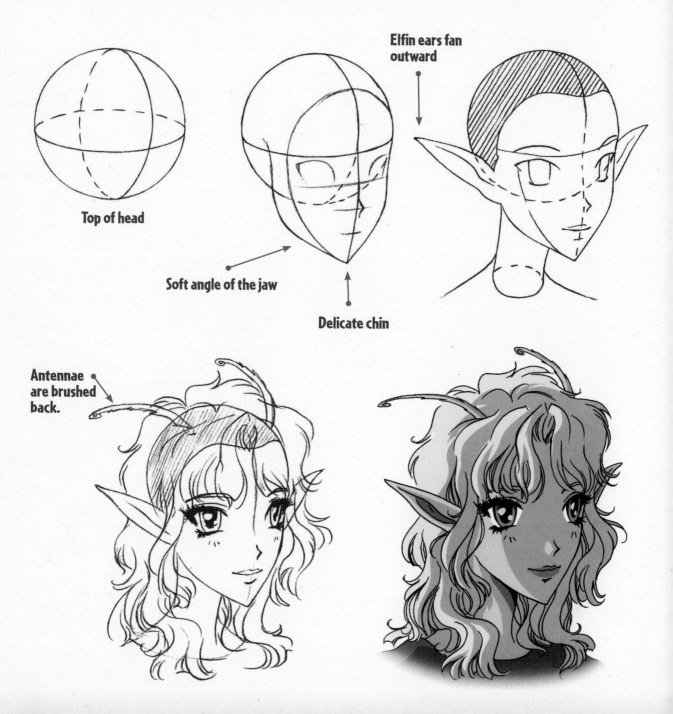

Top of head

Elfin ears fan outward

Soft angle of the jaw

Delicate chin

Antennae are brushed back.

Practice Page

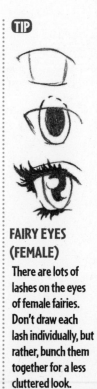

TIP

FAIRY EYES (FEMALE)

There are lots of lashes on the eyes of female fairies. Don't draw each lash individually, but rather, bunch them together for a less cluttered look.

The male fairy has a face that tapers to a small chin. His eyebrows are thick, which adds a masculine accent. His antennae brush forward, while the female's brush back. Why do they bend in different directions? It's simply a technique used to create a different look for each character. The ears, a fairy trademark, are oversized.

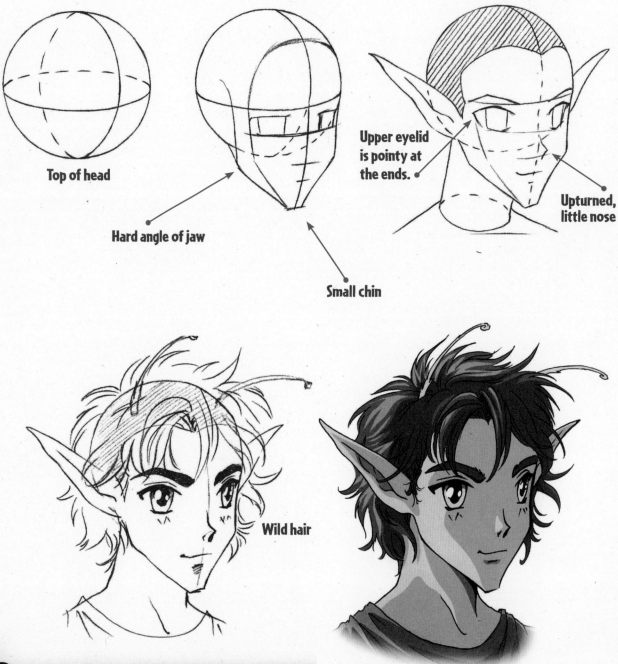

Top of head

Hard angle of jaw

Small chin

Upper eyelid is pointy at the ends.

Upturned, little nose

Wild hair

Practice Page

TIP

FAIRY EYES (MALE)
Follow this step-by-step approach for creating amazing, shiny manga eyes for fairies.

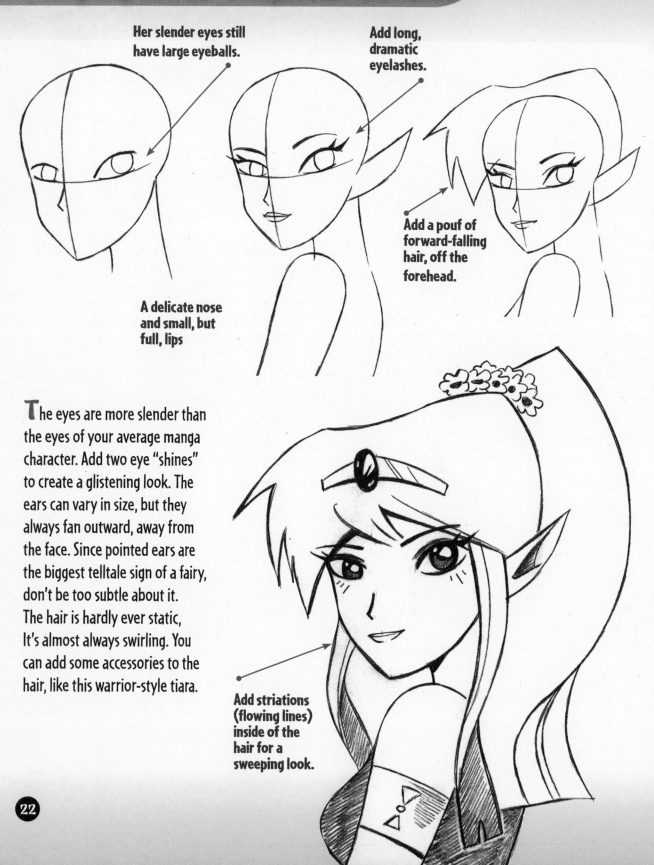

Her slender eyes still have large eyeballs.

Add long, dramatic eyelashes.

A delicate nose and small, but full, lips

Add a pouf of forward-falling hair, off the forehead.

The eyes are more slender than the eyes of your average manga character. Add two eye "shines" to create a glistening look. The ears can vary in size, but they always fan outward, away from the face. Since pointed ears are the biggest telltale sign of a fairy, don't be too subtle about it. The hair is hardly ever static, It's almost always swirling. You can add some accessories to the hair, like this warrior-style tiara.

Add striations (flowing lines) inside of the hair for a sweeping look.

Practice Page

TIP

Almond-shaped eyes are another popular way to draw pretty fairy eyes.

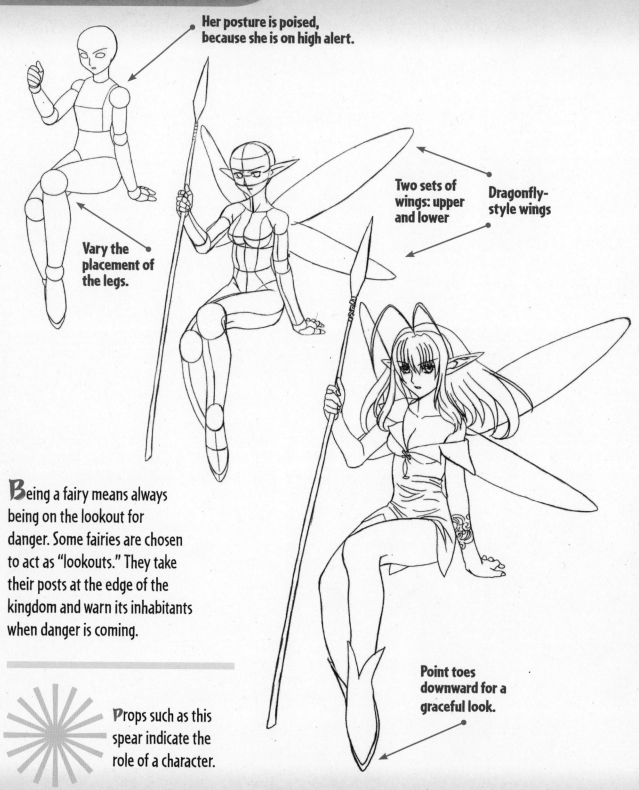

Her posture is poised, because she is on high alert.

Vary the placement of the legs.

Two sets of wings: upper and lower

Dragonfly-style wings

Being a fairy means always being on the lookout for danger. Some fairies are chosen to act as "lookouts." They take their posts at the edge of the kingdom and warn its inhabitants when danger is coming.

Point toes downward for a graceful look.

Props such as this spear indicate the role of a character.

Practice Page

Ever vigilant in defense of her kingdom, this watcher perches herself on a tall blade of grass in order to survey the landscape for signs of trouble. She never rests.

Draw & Color

Wind Fairy

Fairies are often associated with nature's elements, such as the sun, moon, rain, and wind. Each of them requires a visual tie-in. For example, wind is tied to the effect it has on this fairy's hair and clothing. To further enhance the effect, random leaves and petals cascade along the breeze.

Body bends forward, creating a pleasing flow to the overall pose

Draw the legs together for an elegant look.

The sleeves "bell" out.

Fiery colored hair

Clothes trail off in the breeze

Practice Page

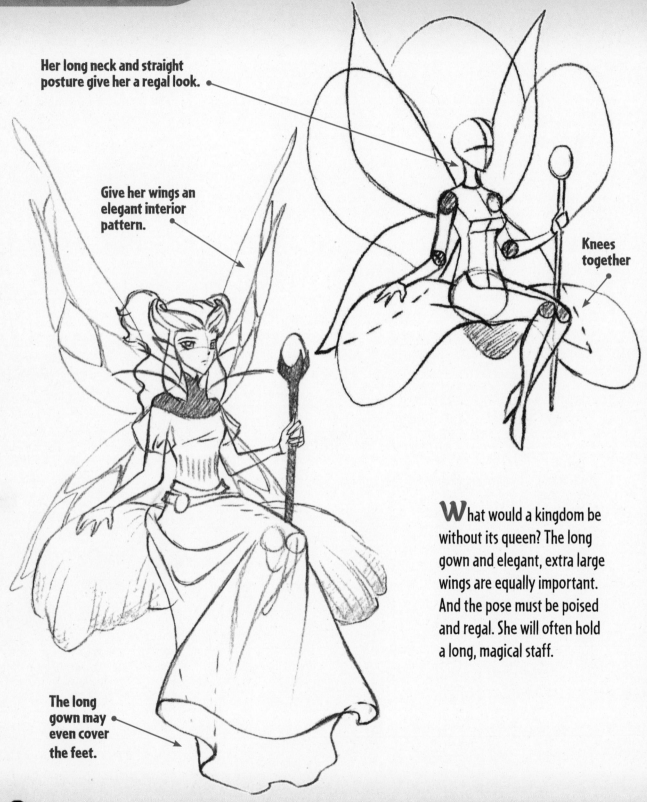

Her long neck and straight posture give her a regal look.

Give her wings an elegant interior pattern.

Knees together

What would a kingdom be without its queen? The long gown and elegant, extra large wings are equally important. And the pose must be poised and regal. She will often hold a long, magical staff.

The long gown may even cover the feet.

While the citizenry of Fairy Kingdom wear garments made of earth tones such as green, brown, and beige, royal characters wear glamorous shades of purple and magenta.

Draw & Color

Chibi fairies can still posses big magic, although it may tucker them out to use it. The adorable quality of this character is created by the oversized head and the compact, little body. The size of the hair is counterintuitive: the larger you draw it, the smaller the character seems to be. The hair buns are a popular trait found in female characters of all manga genres.

The formula is: big head + big eyes + small body.

Keep the elfin ears small on tiny fairies or they will overpower the face.

Hair overlaps the eyebrows

Indent the wings, to create a butterfly look.

Practice Page

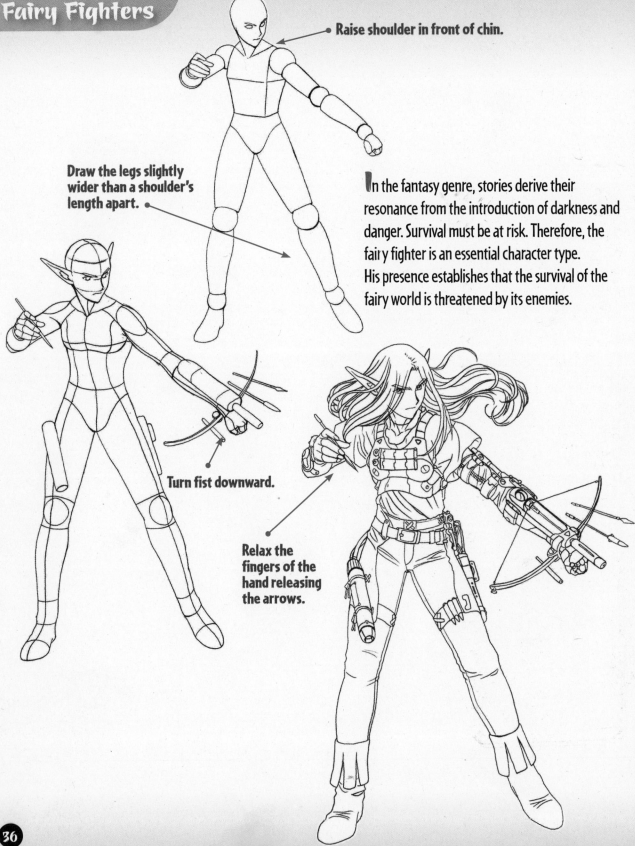

Raise shoulder in front of chin.

Draw the legs slightly wider than a shoulder's length apart.

In the fantasy genre, stories derive their resonance from the introduction of darkness and danger. Survival must be at risk. Therefore, the fairy fighter is an essential character type. His presence establishes that the survival of the fairy world is threatened by its enemies.

Turn fist downward.

Relax the fingers of the hand releasing the arrows.

Practice Page

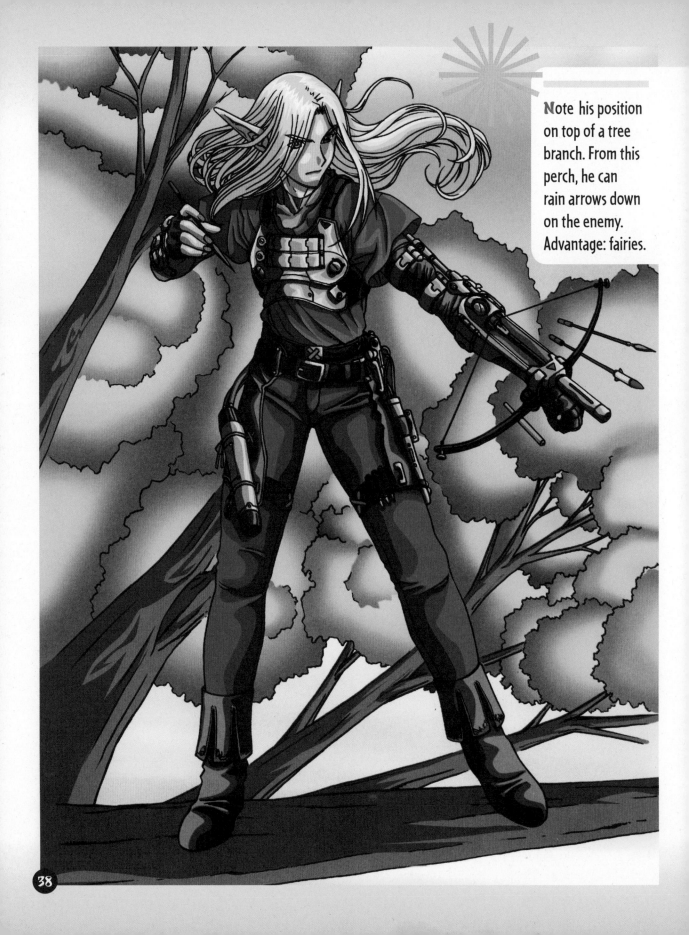

Note his position on top of a tree branch. From this perch, he can rain arrows down on the enemy. Advantage: fairies.

Draw the fairy fighter and background.

Goddesses, Angels, and Demons

In the fantasy genre, there are beings of "light" (good) as well as beings of "darkness" (bad). The bad ones have sinister good looks, while the righteous ones have gentle, innocent expressions.

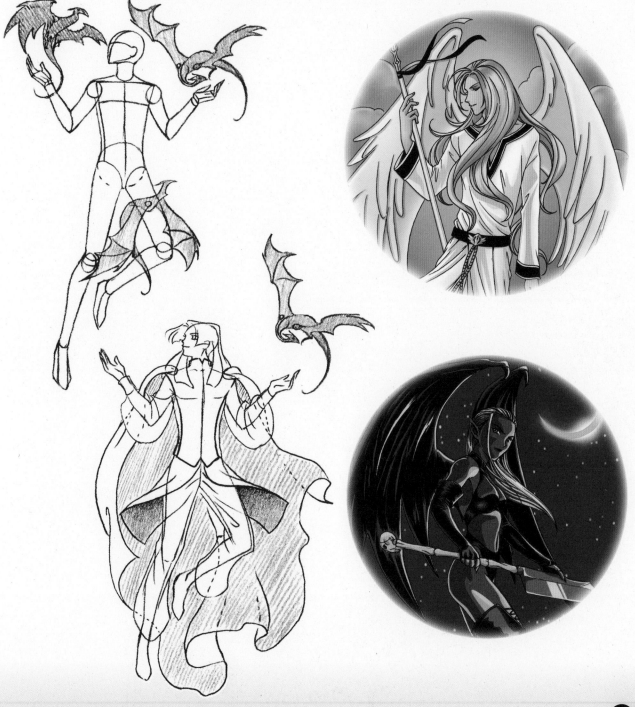

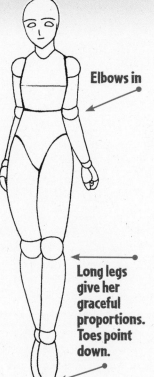

Elbows in

Long legs give her graceful proportions. Toes point down.

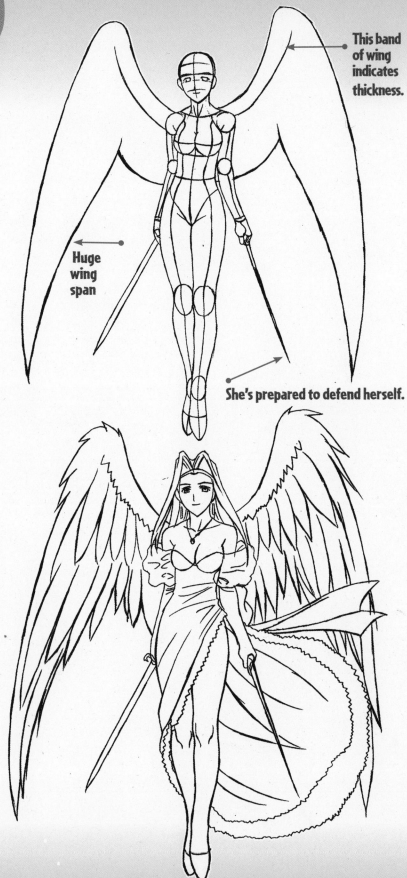

This band of wing indicates thickness.

Huge wing span

She's prepared to defend herself.

Although she may look serene, don't do anything bad to upset her. She's got a sword and she knows how to use it. Although these characters can come to the rescue, they're not always that helpful, offering cryptic riddles instead of lending a hand.

Practice Page

TIP

The feet overlap, which gives the appearance of depth.

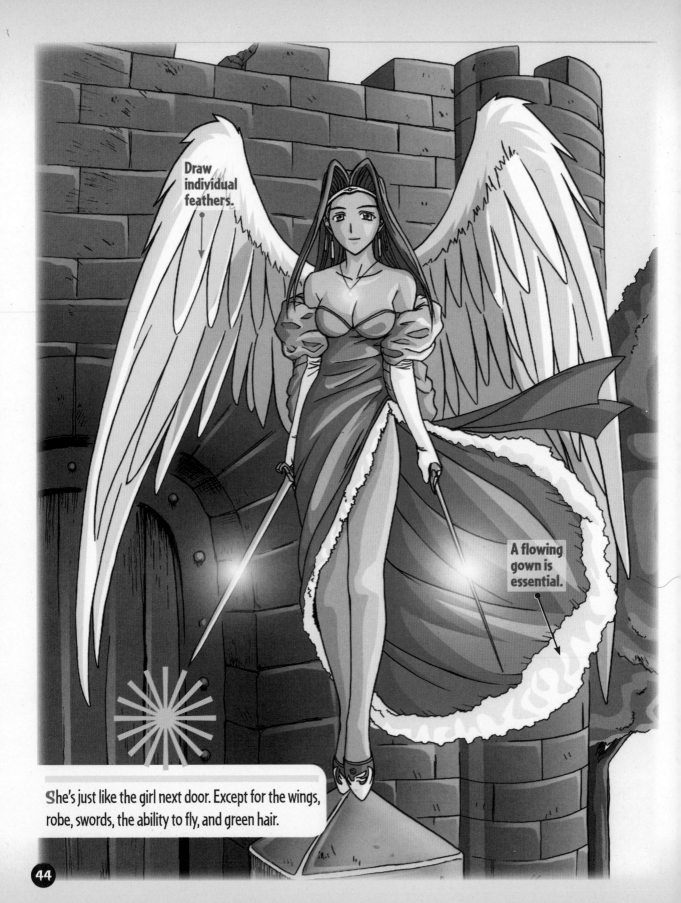

Draw individual feathers.

A flowing gown is essential.

She's just like the girl next door. Except for the wings, robe, swords, the ability to fly, and green hair.

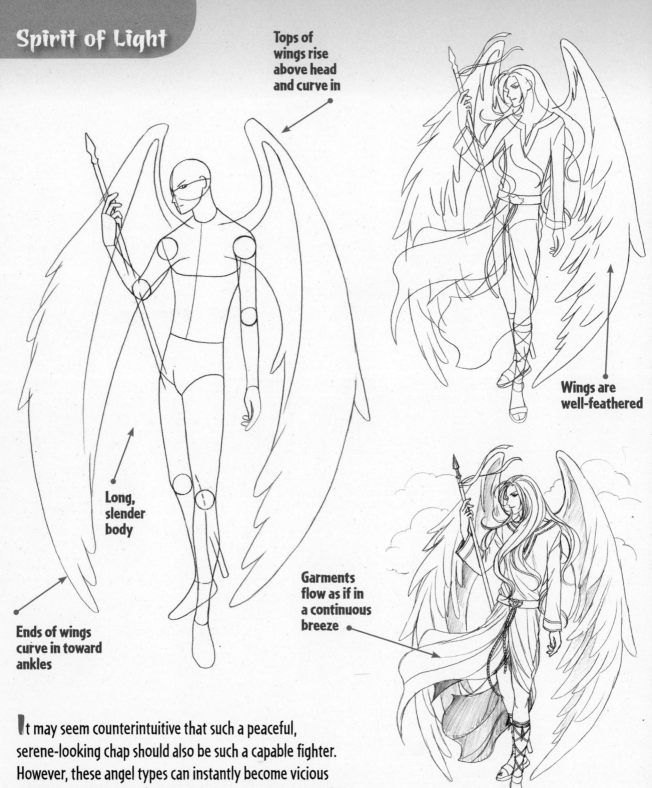

Tops of wings rise above head and curve in

Wings are well-feathered

Long, slender body

Ends of wings curve in toward ankles

Garments flow as if in a continuous breeze

It may seem counterintuitive that such a peaceful, serene-looking chap should also be such a capable fighter. However, these angel types can instantly become vicious opponents when provoked, and they are tough to defeat! This character is always ready to fight for the cause of justice.

Practice Page

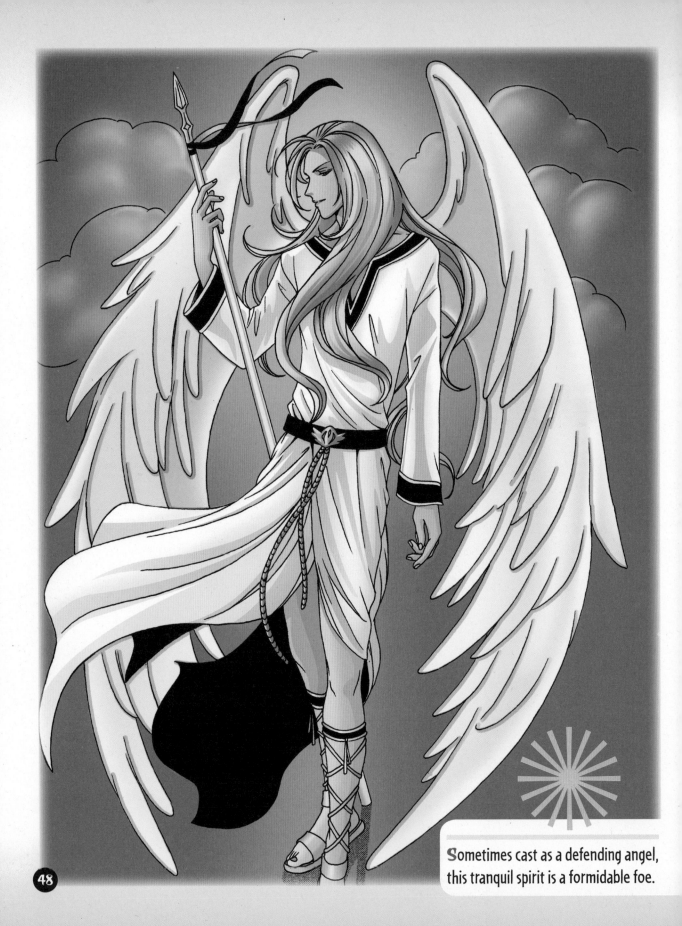

Sometimes cast as a defending angel, this tranquil spirit is a formidable foe.

Draw & Color

TIP

Profile hint:
Features are delicate
and elongated.

Feathered wings work best for good goddesses. The bad ones are drawn with "dragon wings." These wings are made of skin with protruding claws, like those on the pterodactyl, a bird-like creature from the age of the dinosaurs. They have sharp points at the ends.

Body is based on a simple construction. At this point, we haven't defined her as either good or bad.

Draw the wings with sharp tips—a sign of evil.

Note the devil ear, shorter than a fairy's.

This axe-spear has a small skull on the other end.

Practice Page

TIP

Add a small claw at the end of each wing.

Very often, bad characters are nocturnal creatures. (Notice the night sky with the moon in the background.) Scary things look spookier at night.

Draw a nighttime scene using color or shading.

Who doesn't like having a pet? Even evil characters like a little company. Only instead of a puppy with a pink nose, these pets are demon spirits.

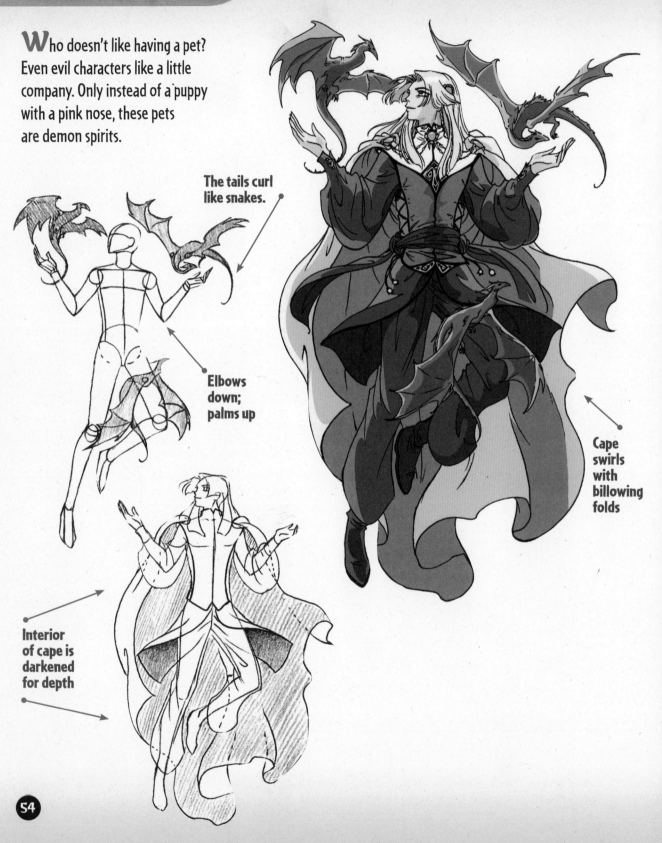

The tails curl like snakes.

Elbows down; palms up

Cape swirls with billowing folds

Interior of cape is darkened for depth

Practice Page

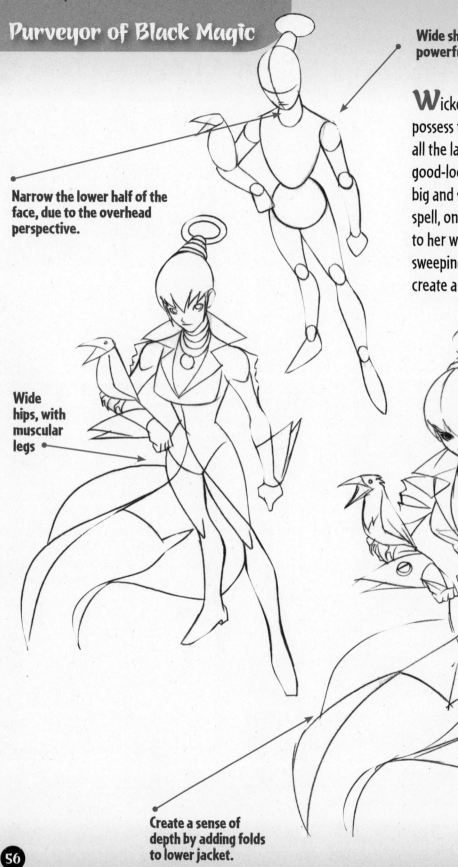

Wide shoulders give her a powerful presence.

Wicked fantasy characters possess the most powerful magic in all the land. These character types are good-looking and alluring. Creatures big and small fall hopelessly under her spell, only to end up as eternal slaves to her will. The sharp collar and the sweeping back vents of the jacket create a dramatic look.

Narrow the lower half of the face, due to the overhead perspective.

Wide hips, with muscular legs

Create a sense of depth by adding folds to lower jacket.

Practice Page

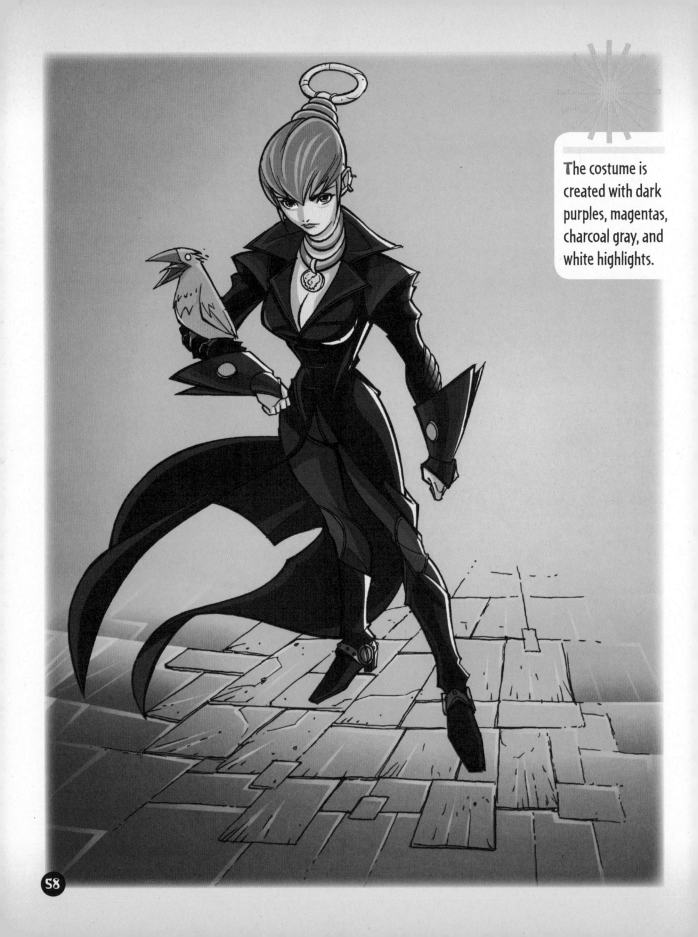

The costume is created with dark purples, magentas, charcoal gray, and white highlights.

Draw & Color

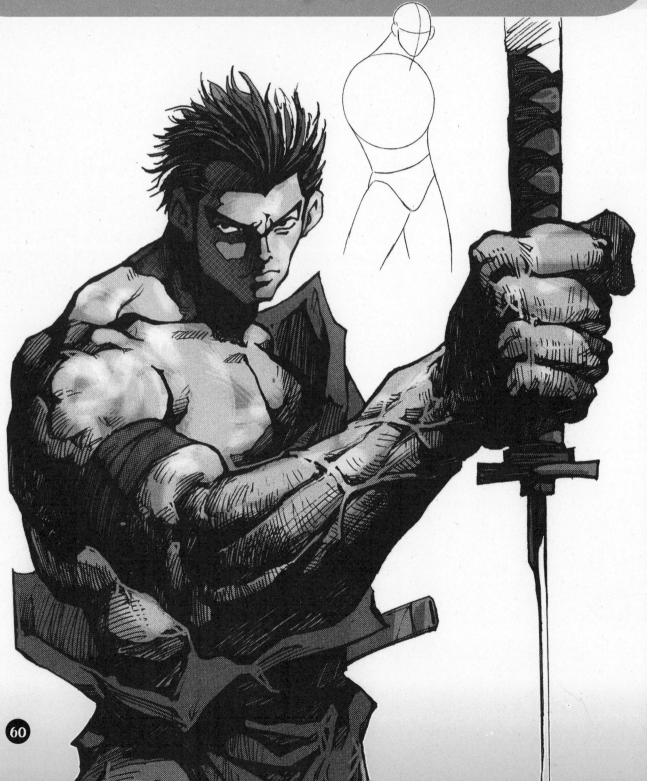

From ancient samurai to pop culture heroes, the characters of swordplay stir the imagination. These masters of the blade are exciting fantasy and adventure characters of manga. Instead of relying on special powers to defeat their enemy, these fighters rely on their amazing skill to defeat multiple opponents at the same time.

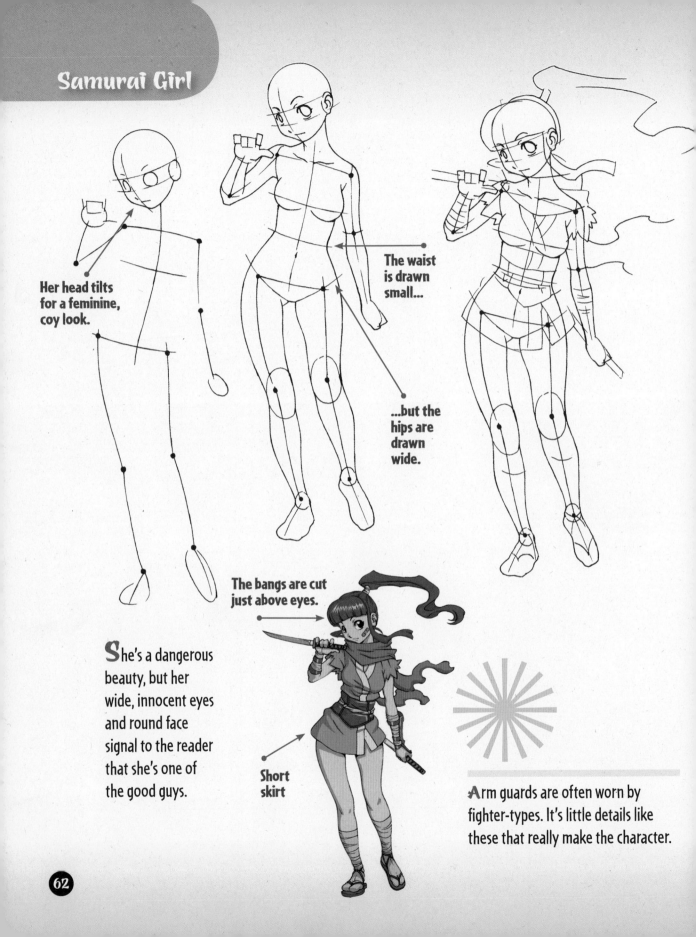

Her head tilts for a feminine, coy look.

The waist is drawn small...

...but the hips are drawn wide.

The bangs are cut just above eyes.

She's a dangerous beauty, but her wide, innocent eyes and round face signal to the reader that she's one of the good guys.

Short skirt

Arm guards are often worn by fighter-types. It's little details like these that really make the character.

Practice Page

TIP

Tilt hips to give the stance a dynamic look.

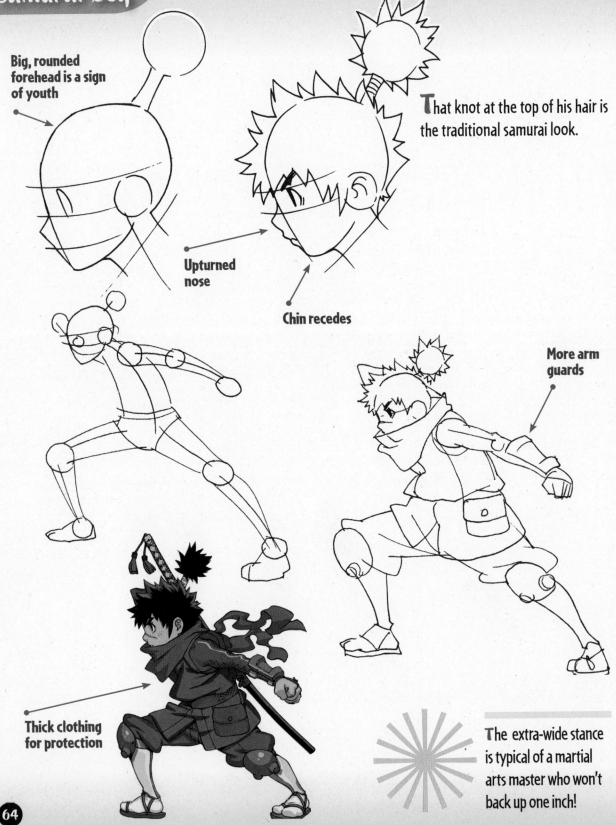

Big, rounded forehead is a sign of youth

That knot at the top of his hair is the traditional samurai look.

Upturned nose

Chin recedes

More arm guards

Thick clothing for protection

The extra-wide stance is typical of a martial arts master who won't back up one inch!

Practice Page

Samurai Man

The loyal warrior has rugged good looks, a square chin, and a strong jawline. He may start out the story wearing his entire outfit, but as the journey gets more harrowing—and as he must fight off bandits, killers, and beasts along the way—he loses part of his uniform and goes shirtless.

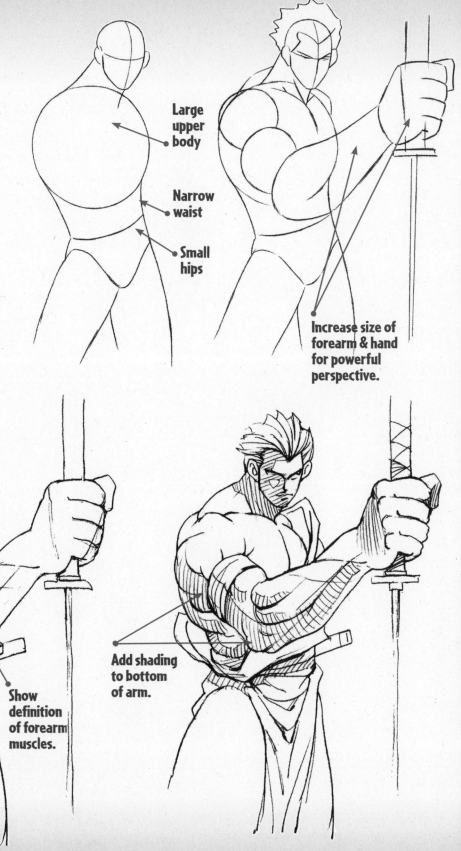

Large upper body

Narrow waist

Small hips

Increase size of forearm & hand for powerful perspective.

Show definition of forearm muscles.

Add shading to bottom of arm.

Practice Page

Exaggerated perspective is a tool that creates intense character poses. In this example, the arm and hand, which appear to be coming toward us, are drawn bigger for a dramatic effect. Doesn't he look more powerful this way?

Draw & Shade

The Long Axe

The spear is taller than the warrior.

Swords aren't the only weapon used by martial arts experts. Some characters use axes mounted on spears. The blade of the axe-spear has many designs.

You can make up your own axe design or try one of these popular styles.

Dual spikes

Top & side spikes

Spear & axe combo

Practice Page

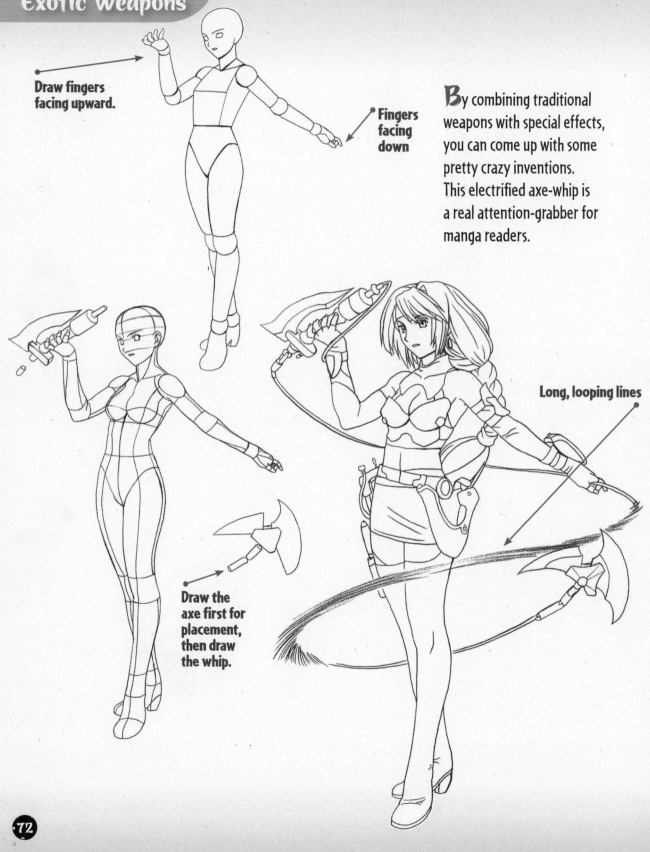

Draw fingers facing upward.

Fingers facing down

By combining traditional weapons with special effects, you can come up with some pretty crazy inventions. This electrified axe-whip is a real attention-grabber for manga readers.

Long, looping lines

Draw the axe first for placement, then draw the whip.

Practice Page

I just want to remind you that this is not a jump rope. We've lost more manga fighters that way. Her confident expression lets us know that she means business.

Bend arm

Bend knee

Extend arm

Extend leg

School-age fighter girls are crossover characters who capture both male and female fans. Although she's a samurai, we have given her the stylish outfit of a lead character.

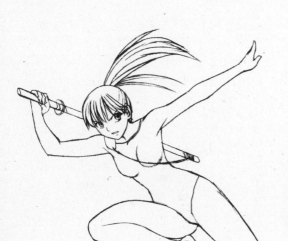

Throwing star, with motion lines

Be sure to show the thickness of the throwing stars, so they don't look two-dimensional.

Practice Page

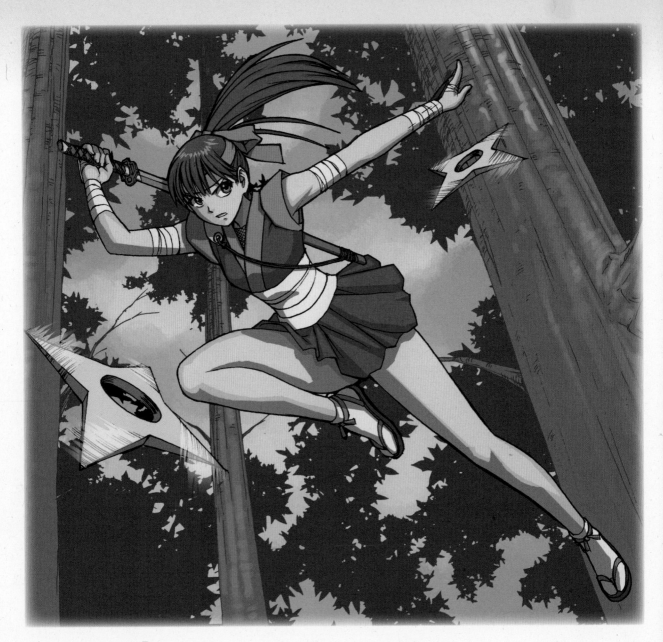

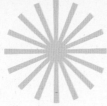 Show the star when it has already left her hand and is traveling toward us. That creates a more dramatic moment than showing it still in her hand.

Draw character and background.

Princesses & Knights

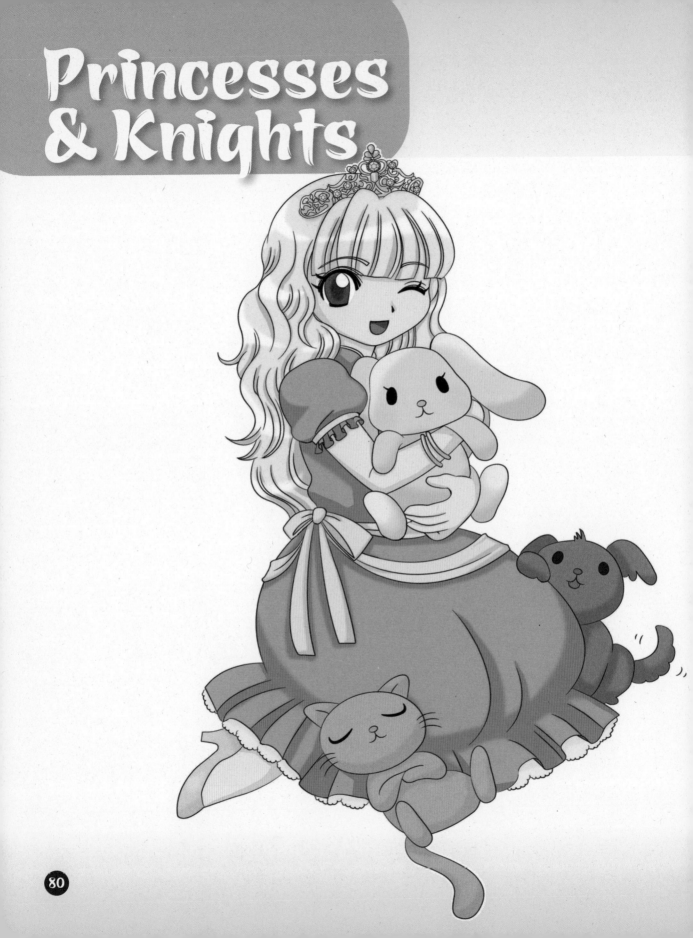

In this chapter, you'll learn how to draw royal and adventurous princesses and other royal character types. Stories that feature these characters take place in the past, present, and future times. Their nobility is typically seen in their ornate accessories, dramatic outfits, and poses.

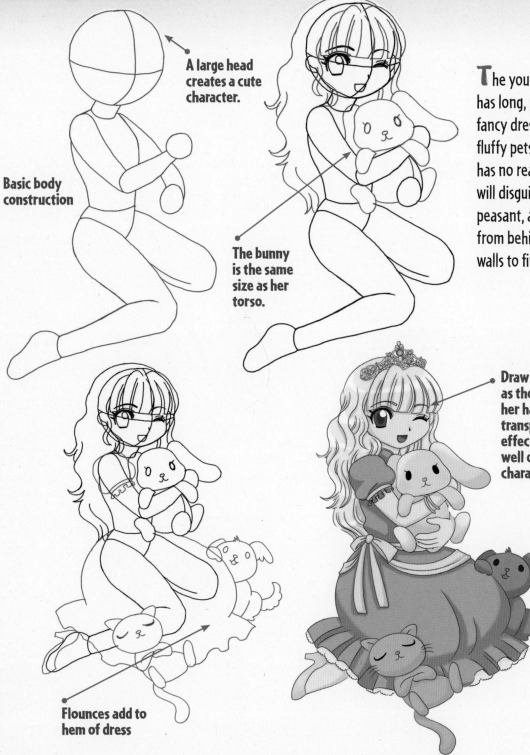

A large head creates a cute character.

Basic body construction

The bunny is the same size as her torso.

The young princess has long, pretty hair, a fancy dress, and many fluffy pets. And yet, she has no real friends. She will disguise herself as a peasant, and sneak out from behind the castle walls to find friendship.

Draw eyebrows as though her hair were transparent. This effect works well on dainty characters.

Flounces add to hem of dress

Practice Page

Ornate tiara

Young Knight

Bring spiky hair forward.

Eyebrows press down on eyes for an intense expression

Oversized chest plate and shoulder guard—you can't be too careful in the Days of Darkness.

Add design element to shield.

The young knight is loyal and brave, but sometimes he can be impulsive. This is his great weakness. He can be goaded into a fight that he can't win. On the other hand, he never gives up. Just when you think he's defeated, somehow he finds the strength to fight on.

Practice Page

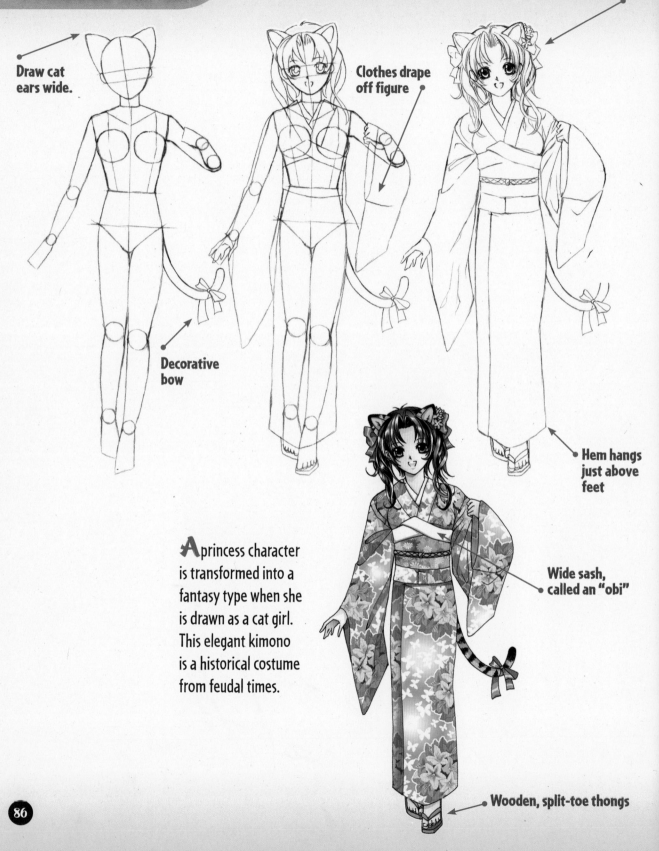

Draw cat ears wide.

Decorative headdress

Clothes drape off figure

Decorative bow

Hem hangs just above feet

Wide sash, called an "obi"

A princess character is transformed into a fantasy type when she is drawn as a cat girl. This elegant kimono is a historical costume from feudal times.

Wooden, split-toe thongs

Practice Page

Fighting Poses: Knights

It gets boring drawing the same angle over and over. This chart shows you how to draw a knight at different angles, so these are called "turn-arounds"– it's a chart to practice drawing the same character in different angles. Practicing this increases one's figure drawing skills.

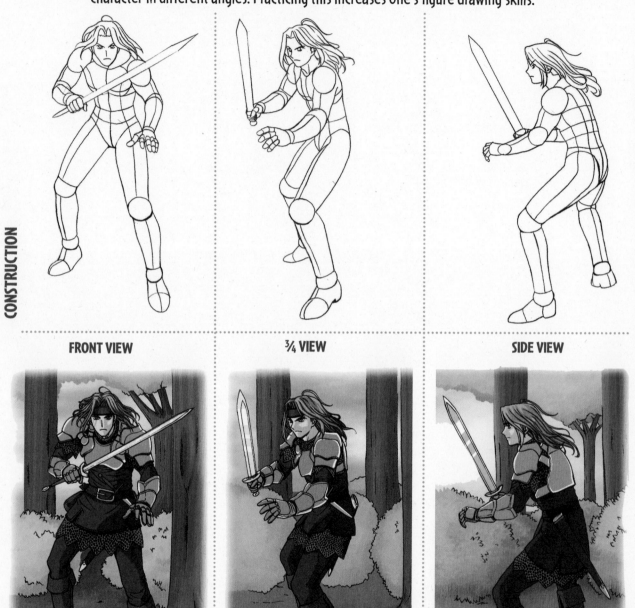

CONSTRUCTION

FRONT VIEW

¾ VIEW

SIDE VIEW

FINISHED

Practice Page

CONSTRUCTION

FINISHED

FRONT VIEW

¾ VIEW

SIDE VIEW

Princess from Another Galaxy

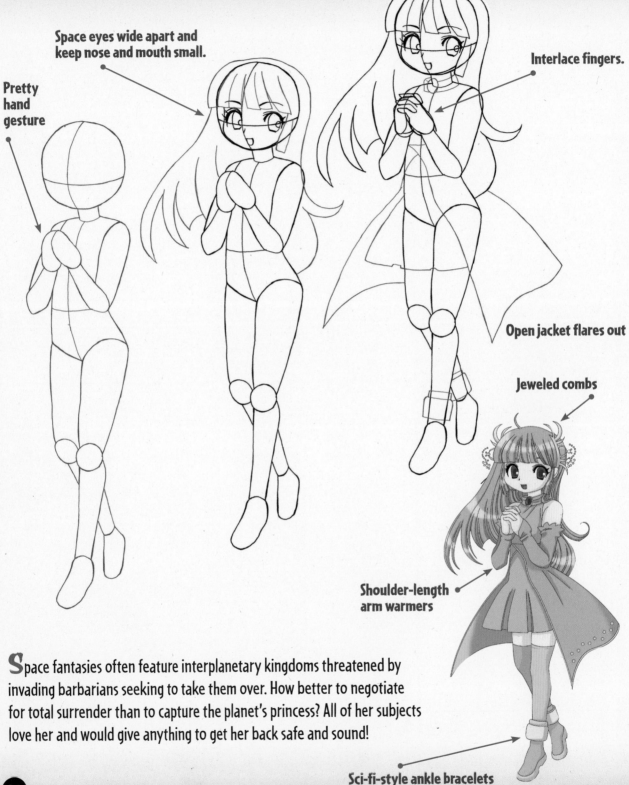

Pretty hand gesture

Space eyes wide apart and keep nose and mouth small.

Interlace fingers.

Open jacket flares out

Jeweled combs

Shoulder-length arm warmers

Sci-fi-style ankle bracelets

Space fantasies often feature interplanetary kingdoms threatened by invading barbarians seeking to take them over. How better to negotiate for total surrender than to capture the planet's princess? All of her subjects love her and would give anything to get her back safe and sound!

Practice Page

Young Hero on Horseback

The young hero leans to the left (page left) so that he can see past the horse's head. But on a more practical level, it also allows the reader to clearly see him. The horse has a mechanical foreleg to enable running at breakneck speed. And check out that high-tech lance!

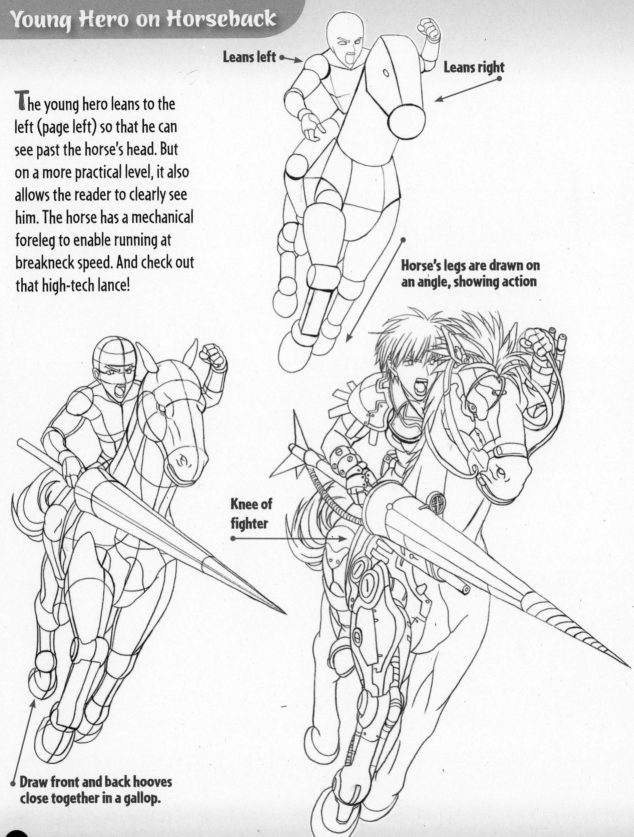

Leans left

Leans right

Horse's legs are drawn on an angle, showing action

Knee of fighter

Draw front and back hooves close together in a gallop.

Practice Page

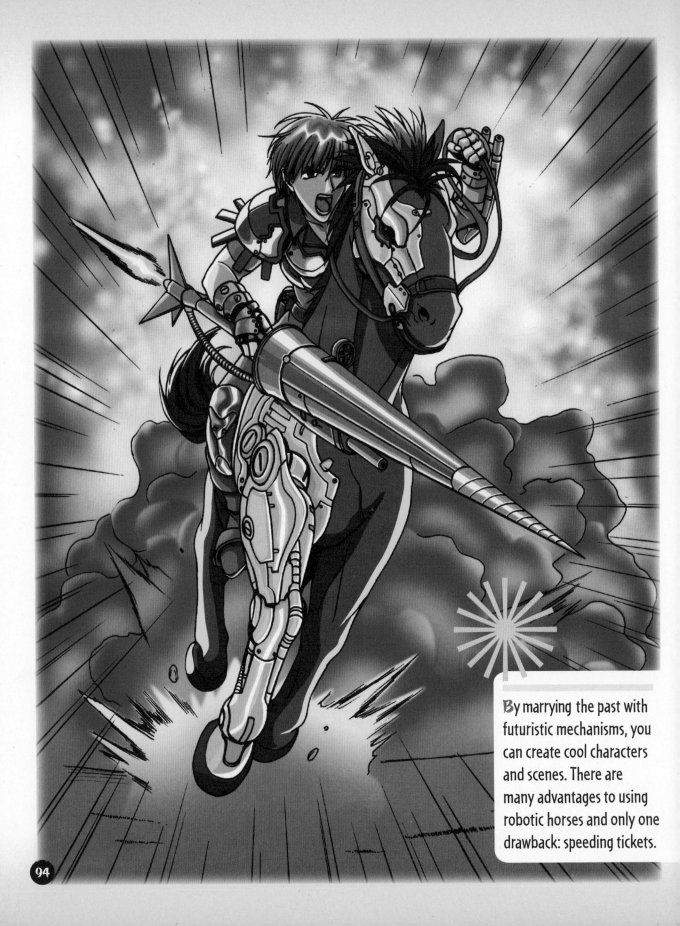

By marrying the past with futuristic mechanisms, you can create cool characters and scenes. There are many advantages to using robotic horses and only one drawback: speeding tickets.

Magical Characters & Powers

There are three basic types of magical powers. The first comes from the character itself, like the ability to shape-shift. The second comes from something the character controls, like the wind. And the third is something that gives the character special powers, such as a crystal or a playing card.

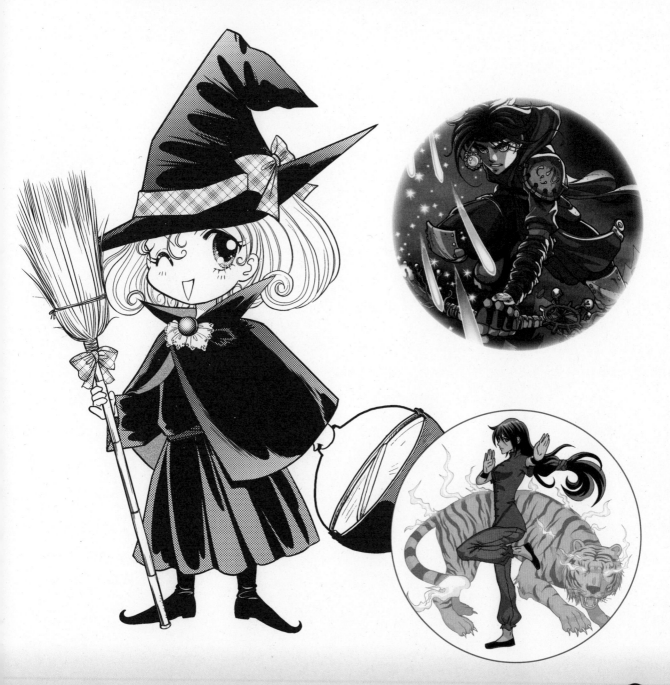

Chibi Witch

Chibis are known for being amazingly adorable with the cutest proportions. Though short and a little plump, this mischief-making chibi witch nonetheless has outsized special powers. Her costume is drawn a bit too big for her, which is a cute look for a little character. Petite and perky, she has tiny hands and feet—and no nose at all! But chibi eyes are always gigantic.

Gigantic head

Tiny body

Small hands and feet

Oversized hat

Cauldron of witch's brew

Practice Page

Fantasy heroes often have a secret—they are cursed! They are part animal and part demon. Therefore, heroes often set out on a journey to find the person who put the hex on them in order to rid themselves of it.

Rigid arm adds strength to the pose

Slope

Heel slopes away from the body

Lock the knee

TIGER GIRL
Notice how flames arise from the tiger's stripes. The tiger represents a style of Shaolin Kung-Fu, so it's a perfect match for this skilled fighter.

Practice Page

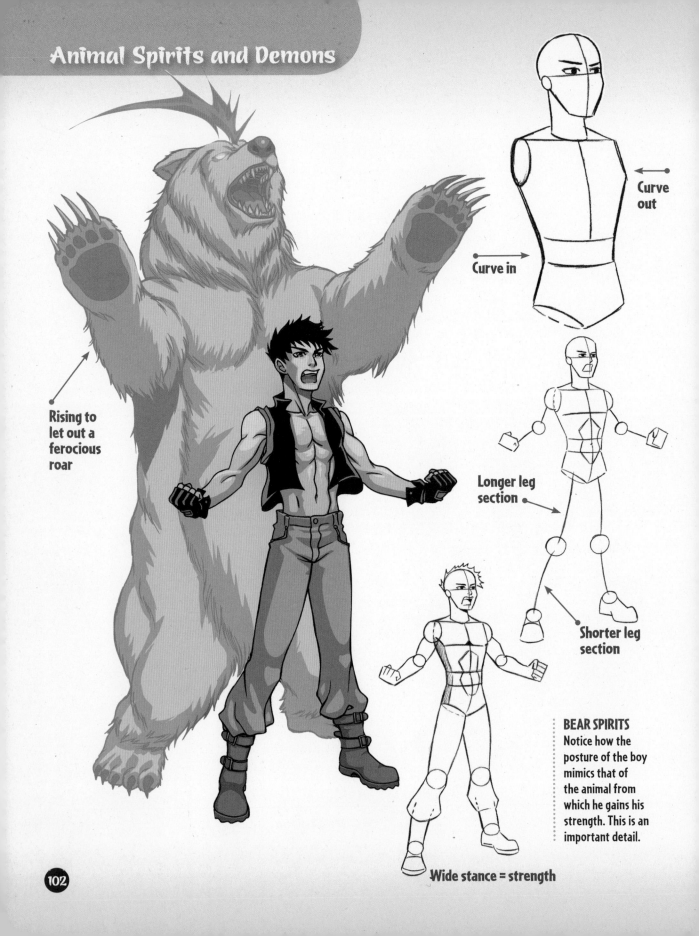

Curve out

Curve in

Rising to let out a ferocious roar

Longer leg section

Shorter leg section

BEAR SPIRITS
Notice how the posture of the boy mimics that of the animal from which he gains his strength. This is an important detail.

Wide stance = strength

Practice Page

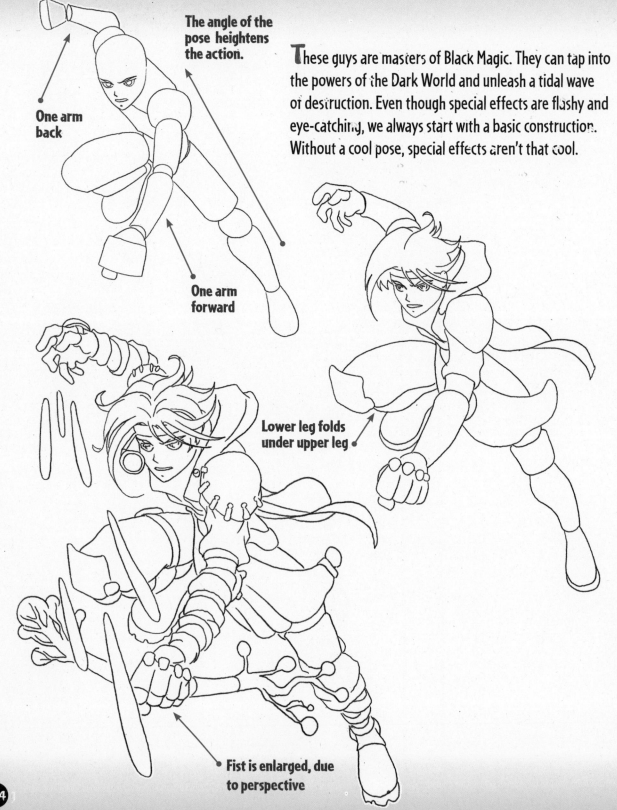

One arm back

The angle of the pose heightens the action.

One arm forward

These guys are masters of Black Magic. They can tap into the powers of the Dark World and unleash a tidal wave of destruction. Even though special effects are flashy and eye-catching, we always start with a basic construction. Without a cool pose, special effects aren't that cool.

Lower leg folds under upper leg

Fist is enlarged, due to perspective

Practice Page

TIP

Detail of fist.

Comets and stars provide the fireworks for these special effects. And the nighttime background causes the special effects to glimmer even more brilliantly by way of contrast.

Draw & Color

Manga is filled with **irrestible,** naughty spirits. These curious beings are created with simple-but-inventive designs and entertaining color schemes. Although they are as cute as can be, they are also wicked. But that's "wicked" with a small "w." Before they wreak too much havoc, let's have some fun drawing these charming troublemakers.

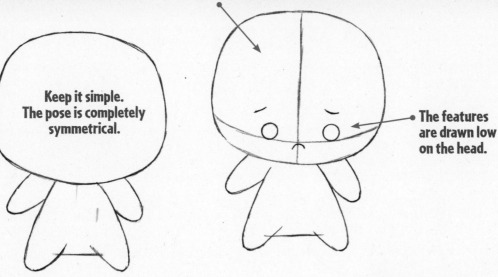

Keep it simple. The pose is completely symmetrical.

Leave lots of empty space for the top of the head.

The features are drawn low on the head.

Who can resist this evil cutie? He looks so harmless. Disarming-but-wicked characters typically use their innocent looks to fool their victims into complacency. There are evil icons all over it—horns, devilish ears, and not one but *two* weaponized tails. And yet, the reader just wants to give it a hug!

Note how the curves of the ears and tails counterbalance each other, again, for a symmetrical look.

Practice Page

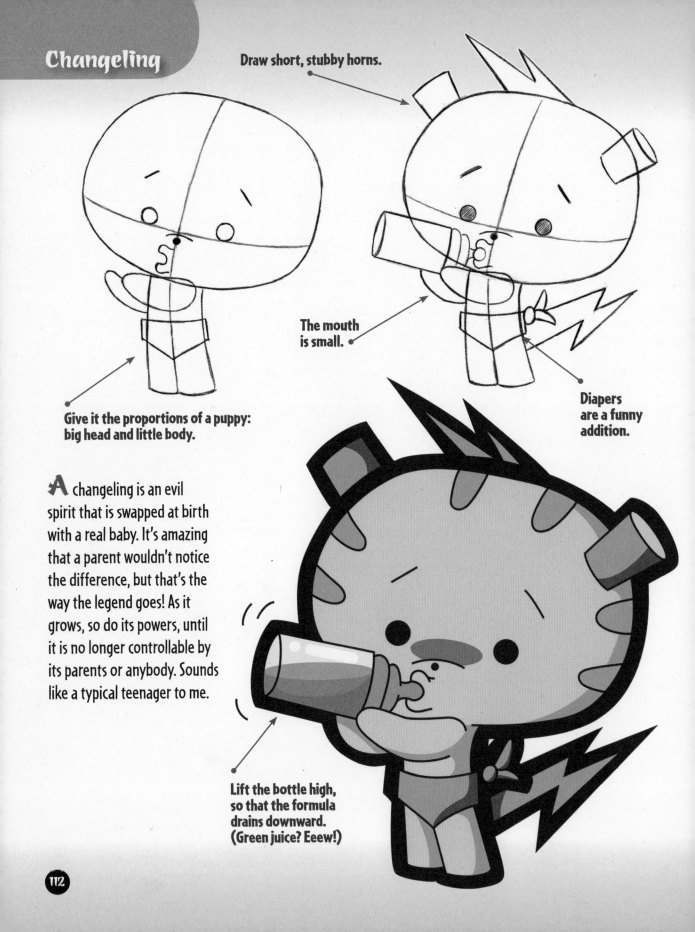

Draw short, stubby horns.

The mouth is small.

Give it the proportions of a puppy: big head and little body.

Diapers are a funny addition.

A changeling is an evil spirit that is swapped at birth with a real baby. It's amazing that a parent wouldn't notice the difference, but that's the way the legend goes! As it grows, so do its powers, until it is no longer controllable by its parents or anybody. Sounds like a typical teenager to me.

Lift the bottle high, so that the formula drains downward. (Green juice? Eeew!)

Practice Page

Another playful
pose. Shoulder
action adds more
"cute" to the look.

These joyful little spirits are favorites among fans of the manga fantasy genre.

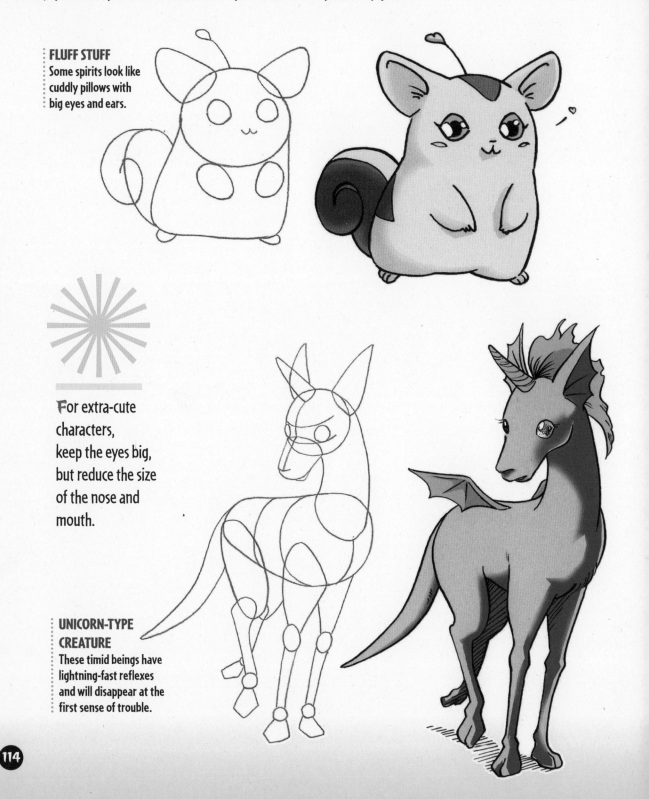

FLUFF STUFF
Some spirits look like cuddly pillows with big eyes and ears.

For extra-cute characters, keep the eyes big, but reduce the size of the nose and mouth.

UNICORN-TYPE CREATURE
These timid beings have lightning-fast reflexes and will disappear at the first sense of trouble.

Practice Page

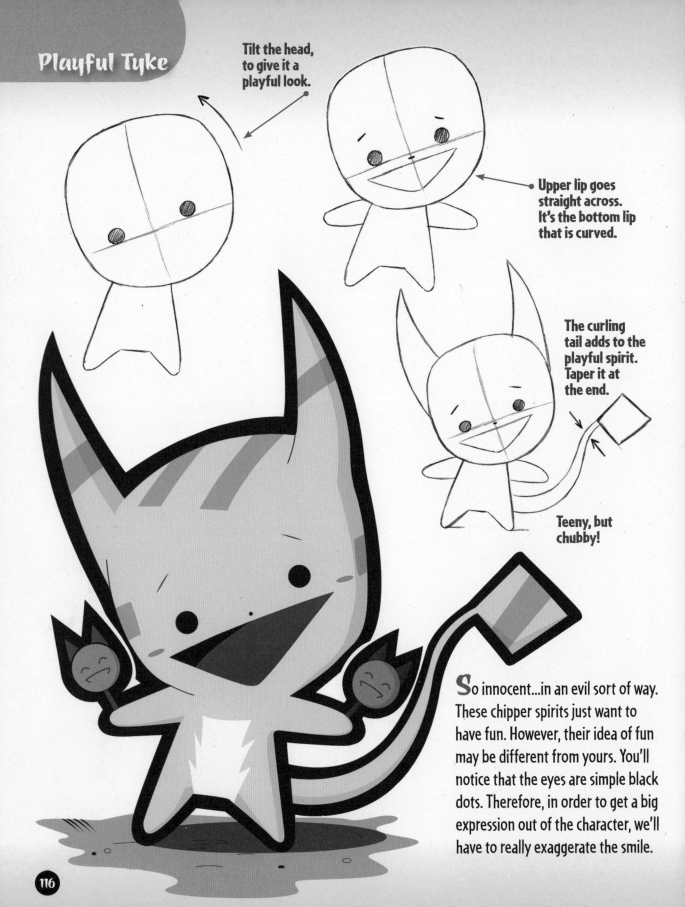

Tilt the head, to give it a playful look.

Upper lip goes straight across. It's the bottom lip that is curved.

The curling tail adds to the playful spirit. Taper it at the end.

Teeny, but chubby!

So innocent...in an evil sort of way. These chipper spirits just want to have fun. However, their idea of fun may be different from yours. You'll notice that the eyes are simple black dots. Therefore, in order to get a big expression out of the character, we'll have to really exaggerate the smile.

Practice Page

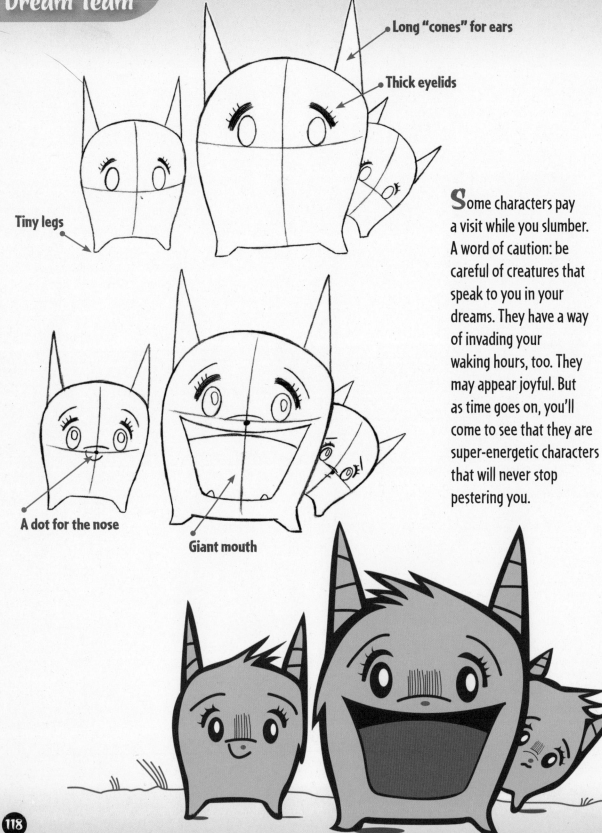

Long "cones" for ears

Thick eyelids

Tiny legs

A dot for the nose

Giant mouth

Some characters pay a visit while you slumber. A word of caution: be careful of creatures that speak to you in your dreams. They have a way of invading your waking hours, too. They may appear joyful. But as time goes on, you'll come to see that they are super-energetic characters that will never stop pestering you.

Practice Page

TIP

The tongue takes up most of the room in the mouth.

Start with a circle (doesn't need to be perfect).

Draw a helmet, and hang the arms from its sides.

Two short legs, spread apart

Pincers for hands

The spikes radiate outward from the center of the helmet.

Imaginary manga characters are often based on large faces with small bodies built around them. This toothy monster is practically all face. By miniaturizing its body, you create humorous proportions that only exist in a fantasy world.

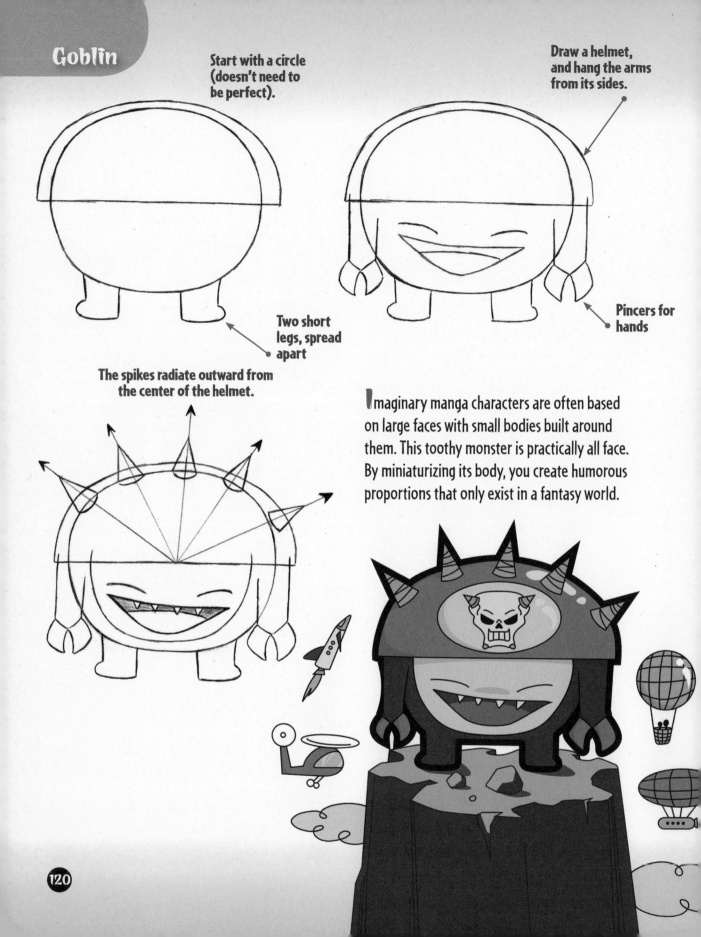

Practice Page

Fantasy Spirits are Everywhere!

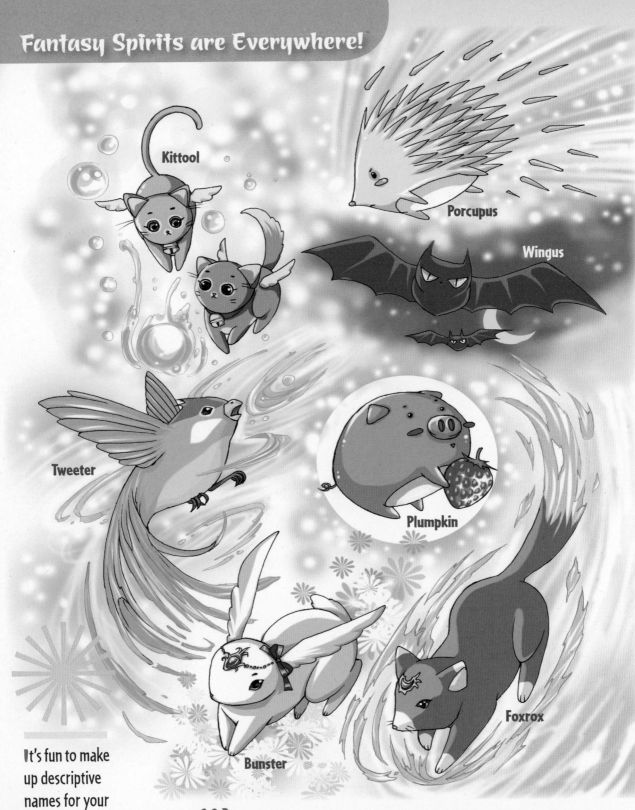

Kittool

Porcupus

Wingus

Tweeter

Plumpkin

Bunster

Foxrox

 It's fun to make up descriptive names for your characters.

When one of these rascals chooses you as its friend, it becomes your friend for life, which can be incredibly inconvenient and annoying!

Create your own fantasy spirit creature.

Adventure Characters of Tomorrow

Zoom with me into the future. Tomorrow's world is sure to be exciting, but also filled with danger. Nothing in the future is set in stone yet. You have a chance to alter it with the actions of your adventurous characters.

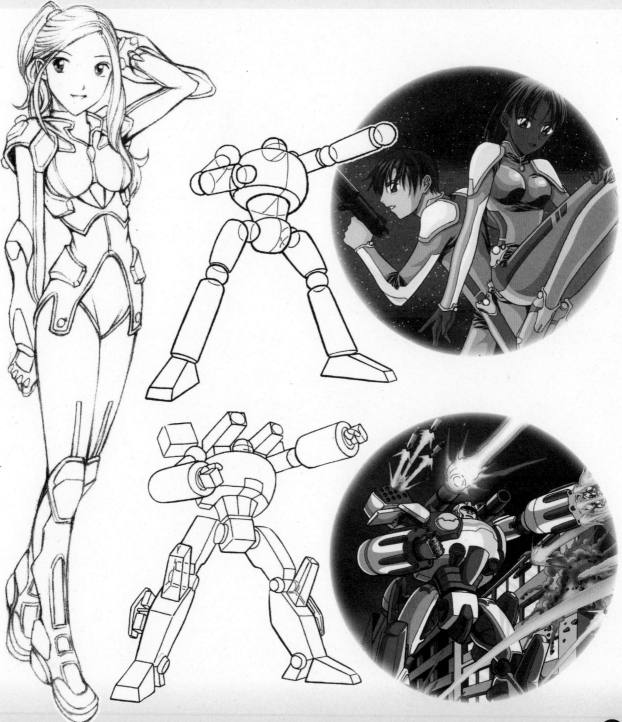

Start with the basic construction of the body before drawing the battle suit.

In a galaxy filled with alien hunters, the world depends on the bravery of a few intrepid teenagers. It's time to suit up, young soldiers!

Create layers of protective gear.

Shoulder guards and elbow guards

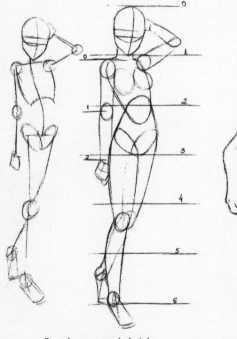

Female commando height:
6 head lengths tall

Earth's commandos are equipped with high-tech armor, which can withstand a battering.

Practice Page

TIP

At any angle, the eyes are in the middle and the tip of the nose is low on the head.

Both guy and gal warriors have a rugged frame.

Highly evolved fighter pilot suit

Add a collar

Elbow and forearm guards

Knee guards

High-tech boots

Male commando height: 6 to 6½ head lengths tall

Practice Page

TIP

Teenage hair
should have an
appealing,
scruffy look.

Sci-Fi Spy

This gal sports the best in futuristic spyware. Her suit, weapons, and gear are all aerodynamic—designed for speed—and a cool look!

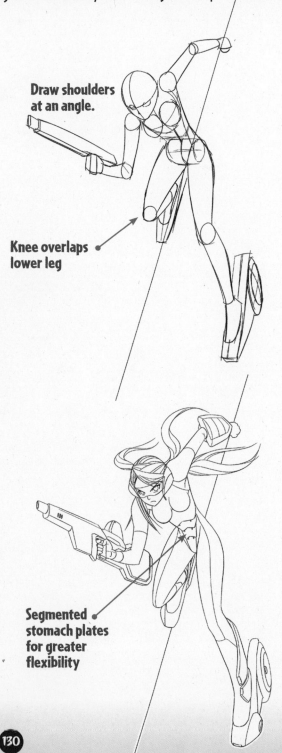

Draw shoulders at an angle.

Knee overlaps lower leg

Hair flies back behind her

Wheels look oval in ¾ view

Segmented stomach plates for greater flexibility

Black lines of the uniform add contrast, which makes the figure more interesting.

Practice Page

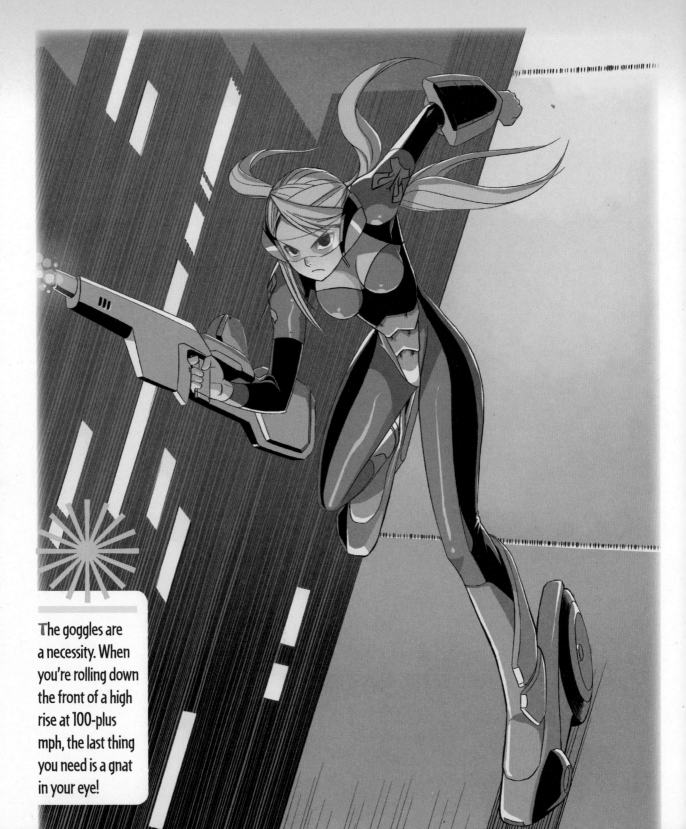

The goggles are a necessity. When you're rolling down the front of a high rise at 100-plus mph, the last thing you need is a gnat in your eye!

Draw & Color

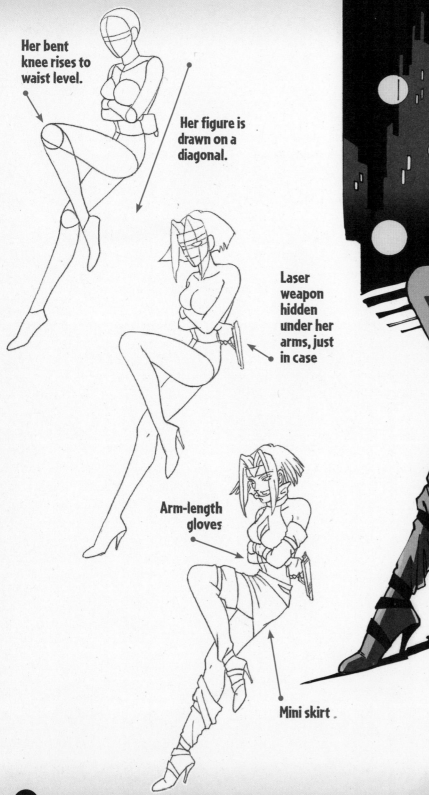

Her bent knee rises to waist level.

Her figure is drawn on a diagonal.

Laser weapon hidden under her arms, just in case

Arm-length gloves

Mini skirt

If you need someone for a dangerous assignment, choose her. But don't let yourself be mesmerized by her beauty—that could be a fatal mistake. This superspy is an expert at tracking and vanquishing her enemies.

Practice Page

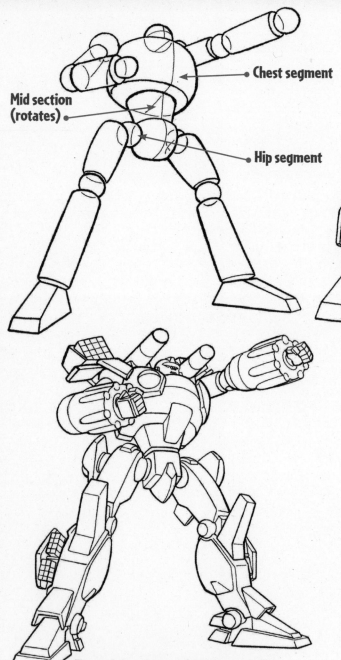

Mid section
(rotates)

Chest segment

Hip segment

Arms are
drawn as big
cylinders.

Each leg has
two planes, front
and side.

Tons of doo-dads make this marauding
machine a high-tech menace.

What do you call a vicious, merciless attacking machine that never gives up? A puppy with a pant-hem in its mouth? Close. It's a giant manga robot. These characters have missiles, rockets, and flamethrowers built into their frame. They don't just attack people, they go after entire towns! It's humanity against a supremely powerful, faceless invader.

Practice Page

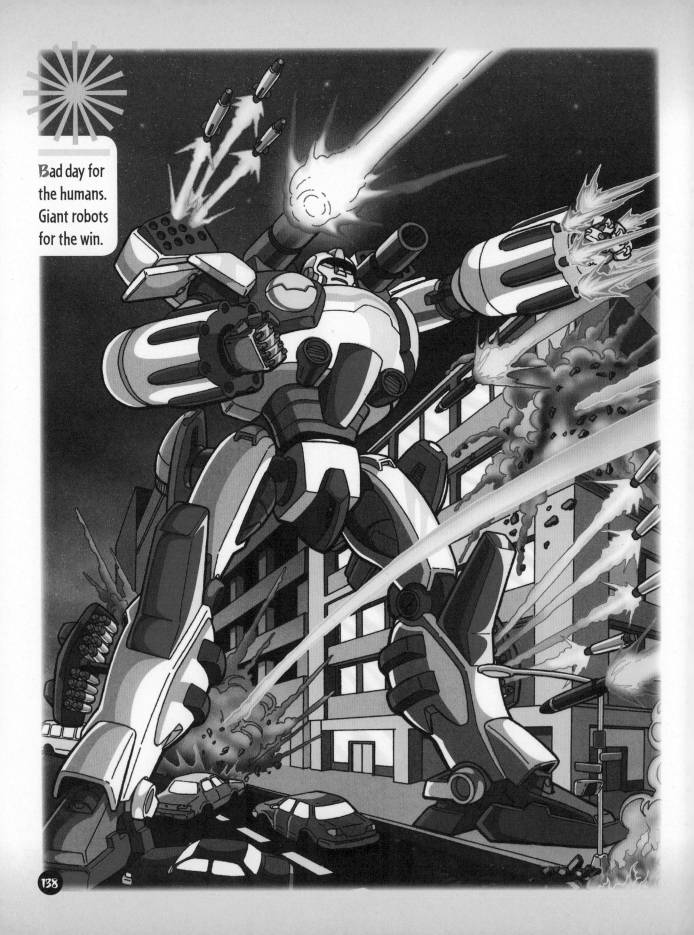

Bad day for the humans. Giant robots for the win.

Draw & Color

TIP

Detail of robot's face

Space Adventures

Due to their youthful builds, these characters are not physically intimidating, and yet their intense expressions let us know that they are formidable fighters. They wear one-piece jumpsuits with shoulder guards. Unlike the bulky spacesuits of today's astronauts, tomorrow's space explorers need light, flexible suits for intense battles.

Draw his head leaning forward—this adds intensity.

The far shoulder is slightly visible.

He may not be bodybuilder strong, but he has wide shoulders and a powerful punch.

Foot sideways

Foot forward

Practice Page

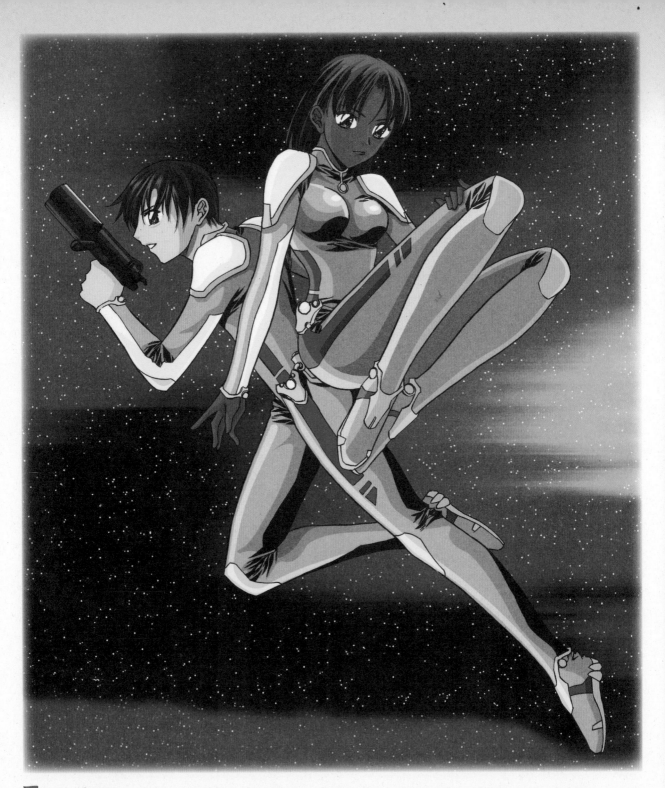

The year: 2099. The place: Earth. Most of civilization has been decimated. The only things left are these young, brave fighters and plastic from some fast food packaging. These characters make Sci-Fi Space Adventure an exciting genre, because the stakes are so high: the very survival of the human race hangs in the balance.

Draw & Color

Practice Page